GEORGE STUBBS

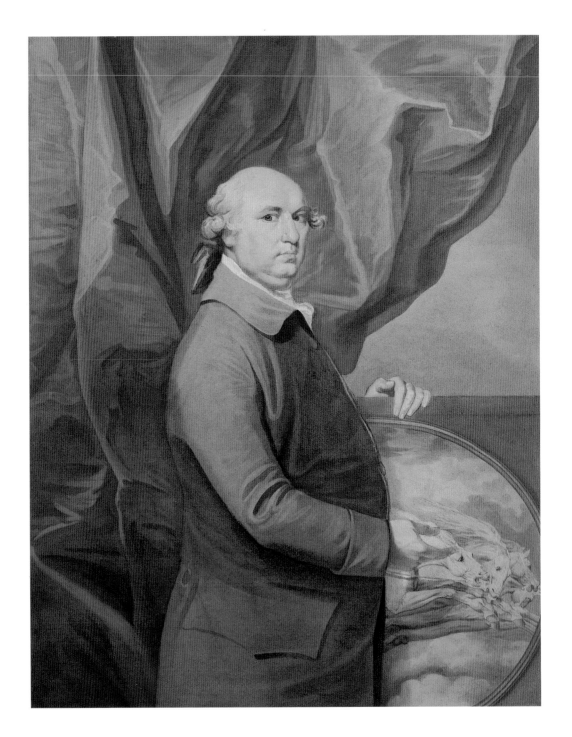

GEORGE STUBBS

Martin Myrone

British Artists

Tate Publishing

Also available in this series:
Francis Bacon Andrew Brighton
William Blake William Vaughan
John Constable William Vaughan
Jacob Epstein Richard Cork
Henry Fuseli Martin Myrone
Thomas Gainsborough Martin Postle
William Hogarth Matthew Craske
Gwen John Alicia Foster
Paul Nash David Haycock
Walter Sickert David Peters Corbett
Stanley Spencer Kitty Hauser
J.M.W. Turner Sam Smiles
Joseph Wright Stephen Daniels

General Editor: Richard Humphreys
Head of Interpretation and Education at Tate Britain

Front cover: *Gimcrack with John Pratt Up, at Newmarket*
*c.*1765 (fig.16, detail)

Back cover: *Cheetah and Stag with Two Indians* 1765 (fig.37)

Frontispiece: Ozias Humphry, *Portrait of George Stubbs*
with 'Phaeton and the Chariot of the Sun' 1777
Watercolour 50.8 × 40 (20 × 15¾)
National Portrait Gallery, London

First published 2002 by order of the Tate Trustees by
Tate Publishing, a division of Tate Enterprises Ltd,
Millbank, London SW1P 4RG
www.tate.org.uk

British Library Cataloguing in Publication Data
A catalogue record for this book is available from the British Library

ISBN 1 85437 433 8

Distributed in the North America by Harry N. Abrams, Inc., New York
Library of Congress Control Number: 2002110468

Cover design Slatter Anderson, London
Concept design James Shurmer
Book design Caroline Johnston
Printed in Hong Kong by South Sea International Press Ltd

Measurements of artworks are given in centimetres, height before width, followed by
inches in brackets

CONTENTS

INTRODUCTION

A Portrait of the Artist as a Young Obstetrician

On a day in some unspecified month sometime around the year 1750 (and perhaps as early as 1746), a twenty-something artist and anatomist with formal training in neither art nor anatomy directed a group of medical students from the hospital at York to procure a body for him to dissect. The body had to be that of a woman in an advanced state of pregnancy. They had heard that a woman had recently died in childbirth in a village some way out of the city. Presumably under the cover of night, the students went to the village, broke open the grave and transported the body back to the artist's attic studio. In secrecy, the artist set about dissecting the woman, carving open her belly to reveal the unborn baby. Her hollowed interior was studied, the foetus, developed and fully recognisable as a little human, was turned over and around, and manipulated into animated postures. The artist took sketches. His observations were to form the basis of a series of small prints intended for the obstetrician, Dr John Burton, who until his recent treasonable involvement with the Jacobite rebellion of 1745, had worked at York Hospital. Untrained in printmaking, the artist had to improvise. Having picked up the basics of etching from a house painter at Leeds, he nonetheless lacked the proper tools for the task. Instead of a professional etching tool, he used a domestic sewing needle stuck into the handle of a skewer. With this makeshift implement he scratched away at wax-coated metal plates, so that in plunging those plates into acid the lines he had drawn would be burned into their surface. To strengthen the design, he engraved directly into the plate, now using sharp tools borrowed from a local clockmaker. Unsurprisingly, the results, included in Burton's *An Essay Towards a Complete New System of Midwifery, Theoretical and Practical* published in 1751, were crude (fig.1). The woman's interior anatomy is reduced to a simple, almost smooth hollow, barely suggestive of human flesh; the baby substantial but, despite the sometimes acrobatic postures contrived by the artist, all too evidently lifeless. In one plate an adult hand appears, highlighting the insufficiencies of the artist in describing the subtle conjoining of the human form. Wooden in its appearance, its presence seems violent rather than clinical. The etched lines which convey these forms do so awkwardly and unevenly: sometimes crowded irregularly together to suggest shade and substance, sometimes describing tentatively the curve of a surface, or nervously tracing the coiling form of the umbilical cord, and very often attempting a course parallel with the previously drawn line, and almost never succeeding.

The plates bear no indication of an author, and nowhere in Burton's text is the identity of their maker given. Yet we know that the artist and anatomist who produced these images was George Stubbs. The incident is recorded in some detail in the manuscript 'Memoir' of the artist, documenting his recol-

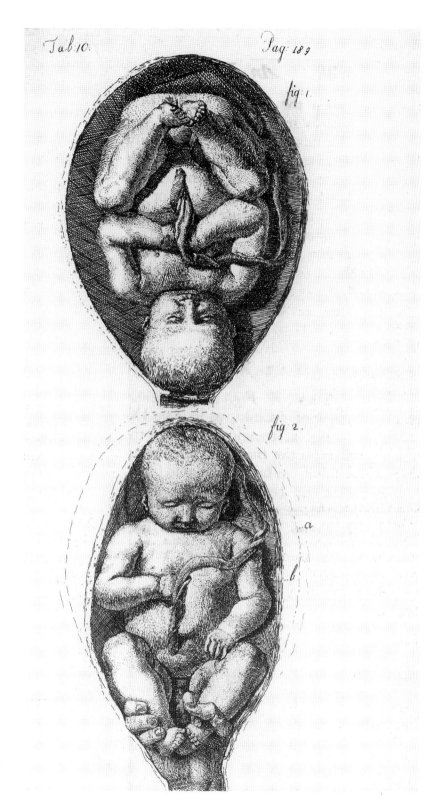

1 John Burton
*An Essay Towards a
Complete New System
of Midwifery*
London 1751, pl.10

lections, as told to his friend the miniature painter Ozias Humphry in 1797.[1] By turns meticulously detailed and frustratingly vague, the manuscript is nonetheless the most important literary document relating to Stubbs, providing essential information about his life, career and methods. The first modern biographical study of the artist, written by Joseph Mayer and published in 1876, was closely based on it, establishing Stubbs as the artist behind Burton's illustrations.[2]

This account of Stubbs as a grave-robber may sit uncomfortably next to the more familiar account of him as the definitive English artist, whose vision of nature and those who enjoy it – whether worker or aristocrat – defines a still vivid ideal of country life. Stubbs's images of horses and the men and women who rode, owned and cared for them are widely prized not just as great works in their genre, but as among the greatest works in the whole history of art (fig. 2). Even while a knowledge of his later intensive studies of animal anatomy forms a crucial part of the conventionally styled appreciation of the artist, the very intensity of those studies, and the exacting, clinical beauty of the drawings and prints which were the result, serve rather to erase any trace of his toil among the grunge of dissection (below, fig. 10). In Stubbs we find 'the one true classical artist that England has produced' whose sense of design and piercing observational skills elevated him from among his peers and above the 'banality' of his subjects.[3] Here is an artist who imbued his images of horses and other animals with a sense of grandeur and stillness that was otherwise meant to be reserved for the most elevated kinds of literary or historical subject matter, whose depictions even of the most ferocious inter-species violence are invested with the formal balance and exquisite technical beauty of the Laocoon.[4]

Although dutifully if rather demurely noted in modern accounts of the artist's output, Stubbs's plates for Burton's *Essay* have not drawn a great deal of attention. They are all too clearly products of an immature artist, unsure of his descriptive capacities or the techniques he was obliged to employ in the production of these plates. They compare badly with the standards of

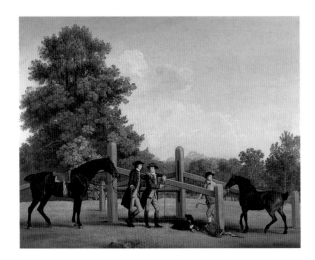

2 George Stubbs
The Third Duke of Portland and his Brother, Lord Edward Bentinck, with Two Horses at a Leaping Bar 1766–7
Oil on canvas
102.9 × 127.6
(40½ × 50¼)
Private Collection

anatomical illustration of the day, and more badly still with the breathtaking achievements of the artist's later years. Yet while undeniably uncharacteristic of the artist's output in their technical quality, their production does conform in some important respects to the received image of the artist. From his day through to our own, there has been a tendency to emphasise the artist's heroic physical capacities. This emerges as a theme in accounts of his anatomical studies. We are told in his obituaries that such was his dedication to dissection that 'he very frequently braved those dangers from putridity, &c. which would have appalled the most experienced practitioner' and even that in procuring bodies he had a 'hundred times, run into such adventures as might subject any one with less honourable motives to the greatest severity of the law'.[5] There is even a story of his carrying single-handed the body of a horse upstairs to his studio, a testimony to his considerable physical strength, sustained perhaps by a famously frugal lifestyle which saw him undertaking arduous walks and shunning alcohol. At his death, it was reported that 'he enjoyed an excellent state of health; was remarkably abstentious; eating only little food, and drinking only water, for the last 40 years'.[6] Modern accounts have agreed that his 'life deserves the word heroic', although as much for his ability to rise from the cultural margins and forge an art of exceptional beauty as for his horse-carrying capacities.[7]

The artist's father, John Stubbs, a Liverpool currier, reportedly objected to his son's artistic interests. So, as a boy, Stubbs was obliged to work for his father, and it was only after the latter's death that he was able to make a commitment to art. Apart from a short time, perhaps only weeks, when he worked with the provincial artist Hamlet Winstanley copying pictures at Knowsley Hall near Liverpool in 1741, Stubbs was self-trained. From the creation of the plates for Burton through his self-publication of the *Anatomy of the Horse* plates of 1766, to his experiments with copper and Wedgwood ceramic supports and fired enamels, and the anatomical studies of humans and animals that occupied him in the last years of his life, the notion of improvisation and experimentation have been of great significance in the appreciation of his art. His 'tastes' were those of 'an experimenter and observer', we are told.[8] And of a recently rediscovered drawing of Stubbs etching, it has been noted that he is shown 'improvising – using old tools for new purposes' and holds the copperplate incorrectly, not like a professional printmaker who would position himself so as to be able to turn the plate with ease (fig. 3).[9]

This notion of the artist's unconventional approach to technique finds a context in his personal and professional life. While we have some of the bare facts about his family, mystery still surrounds his relationship with Mary Spencer, who from the mid-1750s until his death lived with him and assisted him in his art and his scientific pursuits. Although referred to as an aunt or niece in the early literature on the artist, there now seems little doubt that she was his common-law wife and the mother of George Townley Stubbs who also became an artist. But doubts about this are still raised, and it has been claimed that George Townley Stubbs was part of a family formed by the artist with another woman that was abandoned when he took up with Mary Spencer.[10] More seriously, Stubbs's relationship with the major art institution of his time

is similarly ambiguous. The Royal Academy, founded in 1768, was established as the most prestigious artists' group and exhibiting society, but Stubbs held out for years from applying for membership, sticking with the increasingly marginal Society of Artists. Yet while he eventually put himself forward for membership and was elected to its number in 1781, he failed ever to receive the printed diploma that would formalise his membership, because he chose not to present the institution with the obligatory example of his work.

Stubbs's common-law relationship with the Academy highlights his awkward position in the history of art. Born in 1724, Stubbs was part of a generation of artists who in their maturity in the 1750s and 1760s enacted a radical revision of the British art scene, bringing into being many of the institutional and intellectual structures that were to define the modern British art world. When he moved to London in 1758 he was entering a cultural scene that was undergoing a transformation of unprecedented thoroughness and significance. The print market, which had been expanding massively over the previous decades in response to the growth of an urban middle class who sought relatively affordable cultural artefacts, emerged as big business, with Britain becoming for the first time an exporter of printed reproductions of paintings, rather than simply an importer of foreign prints. The first annual exhibition of modern British art was held by the newly formed Society of Artists in 1760, and became a regular event, joined by a rival exhibition in 1761 and then in 1769 by the first of the Academy's annual shows. This was the point at which British art, long dogged by a lack of self-confidence and dominated by foreign talent, really came into its own. Stubbs shared in this burgeoning scene, exhibiting frequently at the Society of Artists and at the Royal Academy, and attempting with the publication of prints and the creation of the 'Turf Gallery' in the 1790s to exploit the richly rewarding larger market for art. As the following chapters should make clear, Stubbs's work needs to be interpreted in relation to these new ways of looking at and buying art.

But despite the rich new opportunities for professional progression that appeared in his day, Stubbs's story is not one of unqualified success. While never reduced to poverty, he did not enjoy enormous material wealth. When he died he was said to be in 'indifferent circumstances'.[11] Nor was his critical reputation untainted. If Stubbs's occupation as a horse painter has now largely been reconciled to his status as a great artist, it was a source of great trouble in his lifetime. In his selection of works for public exhibition, the artist

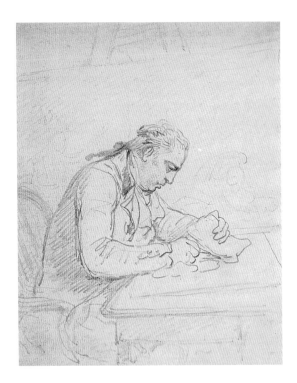

3 Attributed to George Dance
George Stubbs in the Act of Etching
Pencil
19.1 × 15.3 (7½ × 6)
The Royal Collection

tended to emphasise other kinds of painting, making forays into classical subjects, scenes of rustic life and the more dramatic kind of animal painting. On at least two occasions (in 1767 and 1780) he was rumoured to be attempting to give up horse painting altogether. Given that his sporting pictures were rewarding in material terms, this was motivated by a desire for social and artistic status rather than money. The creation of the modern British art world in the 1760s introduced a new emphasis on social pretensions. Within the visual arts, this meant a revival of the rather abstract principles of the hierarchy of the genres. At the top of the hierarchy was history painting, based on scenes taken from classical and sacred literature or depicting great events from history, in a style that was intended to recall the grand traditions of Greece and Rome. At the bottom was still-life painting, which in depicting inanimate objects could not claim narrative interest or intellectual ambition. In between was portraiture, which at least could claim some status in depicting individuals of great personal virtue (or rather, depicting individuals as if they had great virtue). Rather lower down, if not at the very bottom of the pile, were depictions of the landscape and animals, which could not aspire to the intellectual abstraction and virtuous qualities of the higher genres. Moreover, as noted in Chapters 1 and 2, sporting society itself had negative associations that were hard to get away from.

The hierarchy of the genres had originally been formulated in a society quite unlike that of late eighteenth-century Britain. As systematised by the spokesmen of the French academy of art in the seventeenth century, it was a proposal that could only really be sustained in practice by state sponsorship of a kind that did not exist in Britain. This might even be a source of pride. Hogarth, with his theoretical treatise *The Analysis of Beauty* (1753) and further unpublished writings, proposed an alternative ideal of art based on observing common nature and rejecting the elitist, idealist models of high art. But the foundation of the Royal Academy in 1768 marked the triumph of the elitist model of artistic practice. With the massive expansion of the public for art and the ceaseless mutation of social value in the cultural marketplace, who could lay claim to these more exclusive ideals was very much in question.

Stubbs's career spans this period of contest over the very notion of artistic value. As an artist who created works for private, generally aristocratic patrons, but who also published and exhibited his images for a broader market, his art and career moved between an elitist culture that could be wholly self-referential and an emerging public culture for the visual arts. Yet while he had some great achievements in both quarters, he did not successfully break away from being typecast as 'only' a sporting artist. Indeed, the criticism of his day cast him as a very specific kind of animal painter, an artist who was minutely attentive to nature, at the expense of imagination or even painterly pleasure. As explored in Chapters 2 and 3, Stubbs was in a vulnerable position with regard to the ideas about subject matter, painterly style, and the relationships between art and nature that were being employed to define artistic quality.

Perversely, it is precisely the uncomfortable position Stubbs's art occupied in relation to the dominant principles of taste of his day which has led him to

be recovered by the more searching art historical accounts of his work from recent times. His awkward, largely oppositional, relationship with the Academy has been cast as an extension of the Hogarthian anti-academic aesthetic, or more closely tied to the contests within the artistic community of the 1760s and the political conflicts that these represented.[12] His meticulous painterly style and anatomical endeavours have led to him being identified as one of the 'great visual artists of the Enlightenment'.[13] His art has been seen as giving the most perfect visual expression to the great intellectual revolution of the eighteenth century – the 'Age of Reason' – wherein the superstition and stagnant social order of old was eroded and superseded by forms of rationality and intellectual clarity bred in sociable clubs and literary gatherings, ushering in the modern age.

Seen in that light, Stubbs's heroism re-emerges: now he is the artist-scientist struggling against the establishment to forge his vision, whose technical and aesthetic clarity provides a sharp opposition to the clotted surfaces and abstracted idealism of, say, Reynolds, the cultural conservative. Only Joseph Wright of Derby could, it is supposed, equal Stubbs in giving perfect visual expression to the empiricism and rationality of the Enlightenment; and like Stubbs, he pursued a career somewhat outside the establishment, suffering a similarly semi-detached relationship with the Academy. Stubbs's art certainly demands interpretation as an expression of a 'scientific', Enlightenment outlook; but we can also ask more critically what Enlightenment means. With that in mind, it is worth returning to the *Essay* illustrations.

As Jonathan Sawday has written in reference to artistic anatomy in the Renaissance: 'Dissection means examination, but also violence, and any act of dissection is not an abstracted, meditative action created in isolation, but part of a network of practices and structures.'[14] Considered as a prologue to the narrative of Stubbs's career, his dissection of the pregnant woman's body as preparation for the Burton plates conforms to our ideal of him as a hands-on empiricist. Moreover, it connects him with the historical narrative of obstetric practice, which forms a singularly significant thread in the history of scientific Enlightenment. Until the 1720s professional male doctors would only intervene in childbirth in exceptional circumstances, if problems arose. From that date male doctors were increasingly present at all births, and the 'man-midwife' appeared as a professional class. Equipped with forceps, in previous generations a trade secret virtually exclusive to a single family of doctors, men were ever more ready to intervene. This new phenomenon was the source of very considerable unease and controversy – was this new male interest and active participation in the act of childbirth natural, right or safe? The very act of 'touching' (i.e. examining) a woman was seen as morally suspect, suggestive of cuckoldry and sexual exploitation.[15] Burton himself was relatively conservative, proposing the intervention of the male midwife and his forceps only if an aided birth became a medical necessity; others proposed that it should be standard. But even he was later satirised by Laurence Sterne in his novel *Tristram Shandy* (1759–67) as 'Dr Slop' – the name itself conjuring a sense of disgust or even danger that was associated with male interventions in the process of birth.

Even accepting a range of views within obstetric practice, historians have identified man-midwifery as a programmatic attempt to establish male social supremacy, robbing women of the control of their own bodies. Certainly, the rise of man-midwifery meant more business for male doctors, and publications such as Burton's were a potential means of making money, dignifying the profession and establishing a reputation for its author. Introducing his volume, Burton countered the views of the many who dismissed midwifery as undignified and un-intellectual: 'These Sort of Men consider *Midwifery* rather as an *Art*, than a *Science*; whereas it may properly be said to be comprised of both ... both Learning and Dexterity are required' (p.xi). In the mid-eighteenth century the manual aspects of medicine did not have the professional dignity attached to them now. Surgeons, rather like artists over the same period, were greatly concerned to establish the professional and intellectual aspects of their activities through rationalising the manual practices involved. The creation of cultures of professionalism was a great force in the eighteenth century, in which, as both artist and anatomist, Stubbs tried to participate.

Stubbs was said to have begun an interest in anatomy when he was as young as eight years old, that is, around 1732, when a neighbour, Dr Holt, lent him preparations and bones to draw from. After moving to York in 1745, he studied with Charles Atkinson, a surgeon, who provided him with a human body for dissection. That he was so quickly then employed to teach students at the hospital (where Atkinson was the surgeon) may be alarming, but it must be remembered that anatomical knowledge was rare and hard-won. Officially, practical experience in human dissection was available only at the University of Edinburgh, where a single specimen was available annually, and through the College of Physicians and the Barber-Surgeons' company, where a small number of executed men's bodies were received according to a law introduced under Henry VIII. For the most thorough practical training in surgery the student had to travel abroad, notably to the University of Leyden. Yet the period saw an ever-greater demand for this kind of practical training, as surgeons strove to define themselves as a worthy profession, separate from their traditional linkage with barbers. In response, the trade in bodies for dissection grew.[16] The gallows were a prime source, and condemned men would even sell their own bodies to the highest bidder, not least to avoid the unruly scenes between rival anatomists that could follow an execution. But grave-robbing was frequent also. By the 1740s anatomical dissection was established as a conventional part of medical training, and private anatomists were advertising their teaching services in print. Dissection, whether in the few public places it was permissible, or more frequently in the private teaching schools or even in one's own home, was still a shadowy practice, but hardly totally beyond the pale. The narrator of Thomas Amory's picaresque novel of scientific education, *The Life of John Buncle* (1756), reported, without a hint of sensationalism, that having studied an anatomy book 'I cut up the body of a young woman I had acquired from a neighbouring church-yard, and acquired knowledge of enough of anatomy'.[17]

So with Stubbs's youthful involvement in the world of anatomical study and medical illustration, we are led into the heart of the culture of Enlighten-

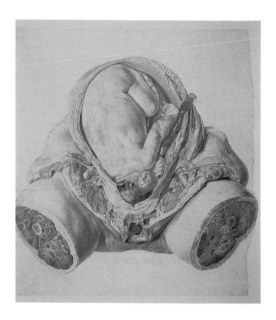

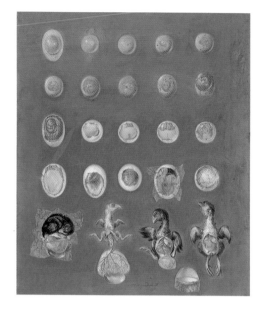

ment, not only as part of the grand procession of modern knowledge, but as a commercial and professional enterprise. In working on an obstetrical manual, Stubbs participated in the rationalisation and even commodification of what had been for centuries a realm of knowledge preserved by women. The 'discovery' of feminine anatomy and of the mechanics of reproduction is a central phenomenon of eighteenth-century culture, articulating not simply a set of scientific ideas relevant only to certain specific intellectual and medical activities, but a new set of values of wider cultural significance. Burton's work was only one of a number produced at mid-century concerned with uncovering, with an explicitness never before seen, the secrets of female reproductive anatomy. It may even have been rushed out to pre-empt a major publication by a rival obstetrician, William Smellie. Around the same time Jan van Rymsdyck began work on the illustrations to a new study of female anatomy of extraordinary ambition, William Hunter's *Gravid Uterus* (finally published in 1774). The resulting illustrations remain startling both for their aesthetic and technical beauty, and their sheer brutality (fig.4). Where Burton had been content with grubby little prints by Stubbs based on observation, but also drawing in a cannibalistic fashion on existing anatomical illustrations, Hunter demanded images as elaborate and refined as the very finest 'high art' prints of the day. If this can be described as marking simply an advance in medical knowledge, we can also interpret it as a great effort to realise visually what had been for so long hidden from (male, professional) eyes. The attention paid even to the texture and detail of the stumps where the subject's legs have been cut off – wholly irrelevant to the anatomical aims of the illustration – testify to the need to present this image as a reality. This 'discovery' of the 'reality' of reproduction was simultaneously the result of the efforts of men to establish their professional and social status in a world of new commercial opportunities. It was an effort to aestheticise and give order to women's bod-

Above left
4 Jan van Rymsdyck
Drawing for William Hunter's 'Gravid Uterus' pl.6, 1750,
Glasgow University Library

Above right
5 Jan van Rymsdyck
The Development of a Chick
Coloured drawing
The Royal College of Surgeons, London

ies, conventionally identified as the prime symbol of nature as a whole. The dissection and documentation of female anatomy was a central project of Enlightenment, but it was also a project that could be said to symbolise and stand in for the process of Enlightenment in its totality. It would encompass not just the illustrations created for Burton and Hunter, but also the coloured drawing by van Rymsdyck showing the evolution of a chick commissioned by William Hunter's brother, John (fig.5), and even, more speculatively, Stubbs's mares and foals subjects, or his painting of a mother and child (possibly an idealising and retrospective depiction of Mary Spencer and their son George Townley Stubbs) (figs.6 and 7). So we have the stages in the development of a chick laid out on an abstracted background, and we have a frieze of animals laid out more naturally but with equal precision for us to observe the relations between mother and child, and trace the transmission of physical qualities over generations (a very great concern in the literature on the care and breeding of horses, summed up in the iterated phrase of one such book of the time – 'Properties descend'). And here, we have a woman drawing back the covers to reveal a baby, recalling Madonna and child imagery, but also the passion for revelation that underlay the efforts of Burton and the Hunters – and their artists (including Stubbs). And behind all of these images, there are the professional and social and economic motivations that fuelled Enlightenment.

It is in relation to these commercial and social processes that Stubbs's art is interpreted here. Perhaps his greatest achievement as an artist was to make those processes disappear from his art. The grunginess and awkwardness of the plates for Burton are alone in his art in conveying some sense of his toil and struggle. If the plates for *Anatomy of the Horse* are so emphatically distant from the carnal house, the ugly little plates for Burton share in the ugliness of the act that produced them. The very clarity of Stubbs's style, and of his vision of nature, may serve as a form of disguise. The main questions which run

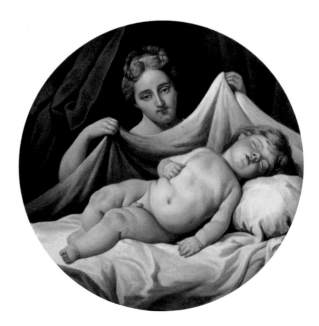

6 George Stubbs
Mother and Child
1772
Enamel on copper
30.5 × 30.5
(12 × 12)
Tate

through the following chapters are, quite simply, not only what do his works reveal – about his ambitions as an artist, about the worlds in which those ambitions were expressed – but also what they hide. As a starting point for addressing these questions, this book tries to look afresh at Stubbs, without assuming that he was inevitably to become a great artist. Chapter 1 considers the earliest period of Stubbs's career, looking again at his trip to Rome in 1754 and the transformative effects of his *Anatomy of the Horse*. Chapter 2 focuses mainly on the 1760s, the period when Stubbs successfully established himself as a leading animal painter, and considers his work in relation to the sporting culture of his day. The distinctive qualities of Stubbs's sporting pictures, the qualities which have made him for so many commentators 'much more' than a sporting artist, are examined as a response to the awkward position of sport in society and the peculiar demands of his patrons. Chapters 3 and 4 encompass the full range of his work from the 1760s to the 1790s, when the artist made great and repeated efforts to diversify and broaden his market. Chapter 3 looks at the 'experimental' qualities of his art, both where it was put in the service of science with his depiction of exotic animals, and his efforts to transform the methods of his paintings. Chapter 4 focuses on his rural imagery, looking at the way this imagery has been recovered for modern audiences, and its original purposes. The final chapter returns to the question of Stubbs's awkward place in art history, looking at the visually awkward qualities of his art, especially his final anatomical project, the *Comparative Anatomy* and the work often considered his 'masterpiece', *Hambletonian*.

7 George Stubbs
*Mares and Foals in a
River Landscape*
c.1763–8
Oil on canvas
101.6 × 161.9
(40 × 63¾)
Tate

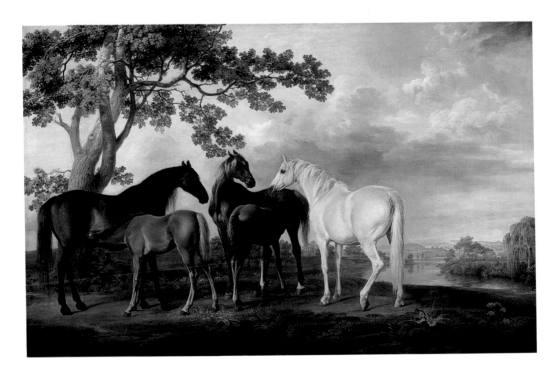

1
'MAKING HIMSELF KNOWN'

In their 1866 *A Century of British Painters*, Richard and Samuel Redgrave wrote of Stubbs that 'Little is known of his early life, or even whether his original bent was to the arts.'[1] Half a century later, this comment was brusquely dismissed as a sign of the deep ignorance about Stubbs's art that had set in during the Victorian era.[2] The Redgraves had, after all, given mistaken information about something as simple as his father's profession, claiming he was a surgeon (though this was an idea that had currency in the artist's lifetime).[3] Yet if we look to Stubbs's activities in the 1740s and early 1750s, we would have to acknowledge that a successful artistic career was far from inevitable. He was equally anatomist, medical illustrator and painter. His brief period with Hamlet Winstanley exposed him to the least distinguished end of the art market. Winstanley was a Lancashire-born painter who, after a few years' training at the Academy run by Sir Godfrey Kneller in London, 'travelled about and drew pictures from life in oyl Colours. often on small pieces of cloth only the face, pasted them when sent to London on larger cloths' where the rest of the picture would be filled in by someone else.[4] He also acted as what amounted to not much more than an artistic odd-job man for the 10th Earl of Derby at Knowsley House.

Stubbs's early years would suggest that he was destined to join Winstanley among the ranks of now forgotten provincial artists. We know that, having split perhaps acrimoniously from Winstanley, he spent a few years at his family home, drawing and studying anatomy. His intention, according to Humphry's *Memoir* was 'to qualify himself for painting Rural, Pastoral & familiar subjects in History as well as Portraiture'.[5] It was, though, the last class of art that was to occupy him, spending periods in Wigan and Leeds, painting portraits. Presumably, somewhere out there, are anonymous-looking pictures tucked away in attics or smothered in years of dirt above the fireplace that are works from this period. But we only know of one portrait, of Sir Henry and Lady Nelthorpe, members of the Lincolnshire gentry, from this early date (as Sir Henry died in 1746) (fig.8). From Leeds he went to York, where he stayed for a number of years. There 'he began a regular course of anatomical study', including the dissection of human bodies, as well as learning 'French & Fencing'.[6] From studying anatomy at the hospital, he went on to teach there, and to execute the illustrations for Burton. Then, in 1751 or 1752, he moved again, this time to Hull, 'always practising Portrait Painting and dissection'.[7] His lifestyle remained itinerant, his professional training more or less non-existent.

It could hardly have been any other way. If the mid-eighteenth century was demonstrably a period of massive expansion in the market for art, there were

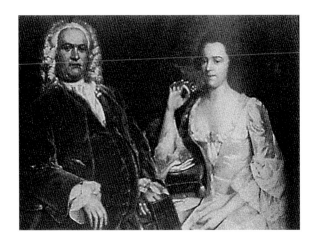

8 George Stubbs
*Double Portrait of Sir
Henry and Lady
Nelthorpe* 1745–6
Oil on canvas
Private Collection

nonetheless no clear structures for career progression in the visual arts. Quite simply, how did you become an artist? There were no formal art institutions, rather clubs whose purpose was primarily social. There was an art school in London at St Martin's Lane, but this was run with a decided lack of ceremony (to the extent that a contemporary dismissed it as 'lame').[8] Art training might be conducted through an apprenticeship to an established painter, but these were private arrangements, the relevant guild, the Painter-Stainers' Company, having lost almost all its authority over the profession in the seventeenth century. Stubbs's father may have been quite right in his anxieties about his son's chosen path in life. There were no formal mechanisms that could organise professional progress, and most certainly no great security.

But by the 1750s one thing had emerged which seemed to promise professional transformation – a trip to Italy. The gentleman's tour to Europe, the Grand Tour, was established in the late seventeenth century. The idea was that before settling down into adult life the young aristocrat should let his hair down by travelling Europe, but especially by visiting Italy, where his eyes would be opened to the esteemed cultural heritage of the ancient and Renaissance world which he, as a Briton, was supposedly heir to. Artistic travel to Rome also emerged over the same period. The years immediately after the Treaty of Aix-la-Chapelle (1748) saw the first great influx of British artists into Italy, including Joshua Reynolds, Joseph Wilton, William Chambers and Robert Adam. Following their celebrated examples, a period of study in Italy came increasingly to appear a prerequisite for any ambitious artist.

In 1754 Stubbs joined this stream of young British artists to Italy. All we know for certain is that, according to local records, he was in Rome by Easter of that year, living at the Piazza di Spagna, the favoured area for British visitors. The sponsorship for this trip is suspected to have come from the Nelthorpe family, though the Earl of Grosvenor was also mentioned in a very early account of his life.[9] In 1754 there were some twenty British artists and architects resident in Italy. Stubbs recalled meeting with the architects William Chambers and Matthew Brettingham, the sculptor Simon Vierpyl, and the painters Thomas Jenkins, Richard Wilson and Gavin Hamilton. All

but the last, who had left some years earlier and did not return until 1756, were certainly in Italy at this time, and all, with the exception of the slightly older Wilson, were like Stubbs in their early thirties and seeking to establish themselves in their respective fields.

Considered alongside the rest of the ex-patriot artistic community in Italy in the mid-1750s, Stubbs stands out as an oddity. For a start, his visit was relatively brief, lasting only a period of months. Most stayed for a few years (and some stayed for the rest of their lives). And while Humphry's biography claims that he 'accompanied the Students in Rome to view the Palaces ... & consider the pictures' he does not seem to have become actively involved in the artistic life of the city as most of his peers did.[10] Among the main reasons for travel to Italy were the opportunities it afforded to study at and associate with the various academies there. Among Stubbs's contemporaries in Italy, Chambers was elected to the Florentine Academy of Design, Dance and Wilton won prestigious prizes for drawing from Italian schools, while Vierpyl and Wilson seem to have taken classes at the French Academy in Rome. Humphry's biography makes a point of stating that 'whilst he resided in Rome he [n]ever Copied one picture or even design'd one subject for an Historical Composition; nor did he make one drawing or model from the antique'.[11] Yet these activities were precisely the ones that artists in Rome were meant to undertake, ostensibly for artistic self-improvement, facilitating the assimilation of the great style in art, but also to secure potentially substantial commissions: the Grand Tour was the occasion when British patrons became uncharacteristically generous, purchasing original compositions and, more frequently, copies after antique and Renaissance masterpieces.

For Stubbs's generation, the artistic Grand Tour of the 1750s was a profound moment of professional self-definition, elevating ambitions and generating a network of useful contacts. Four of the thirty-six founder members of the Academy were there at exactly the same time as Stubbs (Chambers, Wilson, Wilton and Dance) and its first President, Joshua Reynolds, had left only a year earlier. Stubbs did not participate in the creation of the Academy, and one might sense some degree of isolation from the larger artistic community emerging while he was in Rome. He does not seem to have received any commissions, and we know he was back in Liverpool in 1755, for he dated and signed a portrait of one James Stanley in that year. According to Humphry, he picked up pretty well where he had left off, going back to stay with his mother and then going to Lincolnshire to complete portrait commissions for the Nelthorpes which he had received before he went to Rome. But in 1756, when his prospects were really looking no better than they were a decade before, he began the project that was to transform his reputation.

Accompanied by Mary Spencer, Stubbs retired to an isolated farmhouse near Horkstow in Lincolnshire. There, over a period of eighteen months, he dissected a succession of horses, working on each animal corpse for weeks, making detailed drawings and notes that would form the basis for a publication on the anatomy of the horse. He devised an elaborate system for preserving and suspending each body, which he described in some detail to Humphry:

The first subject that he procured, was a horse that was bled to death by the jugular vein; after which the arteries & veins were injected. – A Bar of Iron was then suspended from the ceiling of the room by a Teagle to which Iron Hooks of various sizes & lengths were fixed. – Under this bar a plank was swung about 18 inches wide for the horses feet to rest upon and the animal was suspended to the Iron Bar by the above mentioned Hooks which were fastened into the opposite off side of the horse to that which was intended to be designed; by passing the Hooks thro' the Ribs & fastening them under the Back bone and by these means the Horse was fixed in the altitude to which these points represent & continued hanging in the posture six or seven lenghts [sic] or as long as they were fit for use.[12]

With the horse hanging in position, Stubbs would proceed by 'stripping off the skin & cleaning & preparing as much of the subject as he concluded would employ a whole day to prepare, design, & describe'. Working through layers of muscles and discarding internal organs until he came to the bone, he would move around the body section by section until the whole animal was reduced to a skeleton. He would then proceed on to a new subject. Over the eighteen months Stubbs must have produced numerous drawings, perhaps hundreds: forty-two survive (fig.9).

Even if he received some support from a patron (perhaps the ever-reliable Nelthorpes), producing these drawings meant withdrawing from the world for an extended period, and giving up his portrait practice. It was an enormous and dangerous task (anatomists frequently fell prey to potentially fatal diseases because of their contact with cadavers). It was also entirely original. The only real equivalent was the *Anatomia et dell' Infirmita del Cavallo* by Carlo Ruini, published in 1598 and illustrated with relatively schematic woodcut prints. This had been frequently plagiarised but hardly rivalled by the numerous veterinarian tracts of a more modest nature produced in the eighteenth century. The field was, then, clear for a new publication detailing the anatomy of the horse. In the context of the new interest in scientific publication across a range of fields, and the emerging effort to rationalise the treatment of horses in working and sporting life (noted in the next chapter), Stubbs must have calculated that his illustrations would have considerable appeal. Moreover, there was a gap in the market for an artist specialising in horse pictures. According to Humphry, when he was living with his mother after returning from Italy, a picture dealer called Parsons saw a painting of his depicting his horse, and advised him that he could 'make his fortune in that line of art' if he went to London.[13] Among the leading practitioners of sporting art, John Wootton had given up sporting art to focus on landscape painting, and James Seymour had recently died. Seymour's death had prompted Horace Walpole to jokingly cajole an amateur artist friend to turn to 'horses and greyhounds' as the field was cleared.[14]

So in 1758 or 1759 Stubbs moved down to London, bringing his drawings with him. He sought out engravers who might be able to undertake the work, but was at every turn rebuffed, the printmakers supposedly put off by the enor-

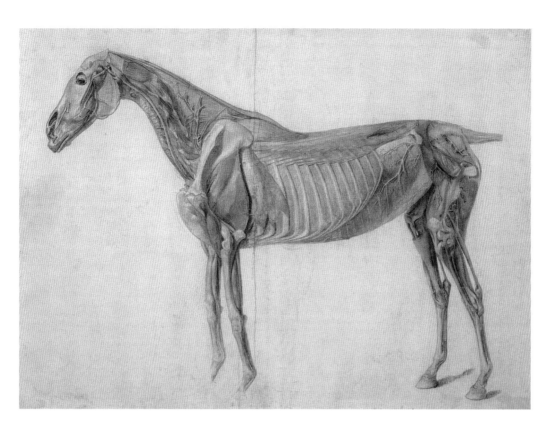

9 George Stubbs
*The Anatomy of the
Horse*, finished study
for the 4th Table
c.1756–65
Graphite 35.6 × 49.5
(14 × 19½)
The Royal Academy
of Arts, London

mity of the task. Instead, he set out himself to engrave the plates, a task that took him years to complete. It was not until 1765 that he issued printed advertisements announcing the publication of his *The Anatomy of the Horse*, and appealing for subscribers to come forward. In these he explained to whom the work was meant to appeal:

> This Work being the Result of many Years of actual Dissections, in which the utmost accuracy has been observed, the Author hopes, that the more expert Anatomists will find it a useful Book as a Guide in comparative Anatomy; and all Gentlemen who keep Horses, will by it, be enabled not only to judge of the Structure of the Horse more scientifically, but also to point out the Seat of Diseases, or Blemishes, in that noble Animal, so as frequently to facilitate their Removal, by giving proper Instructions to the more illiterate Practitioners of the Veterinarian art into whose Hands they may accidentally fall.

Described in this fashion, the work appears eminently practical. In the preface to the work itself, published in 1766, Stubbs added that he hoped that 'it might prove particularly useful to those of my own profession', meaning, of course, artists (the title page identifies the author as 'George Stubbs, Painter'). The eighteen plates which comprise the *Anatomy of the Horse* show the animal stripped of its skin, of the first layers of muscle, and as a skeleton, viewed from a number of angles (fig.10). In each case the horse is posed to appear mobile

21

TAB. IX.

10 George Stubbs
*The Anatomy of the
Horse* 1766, pl.ix
Tate

(a convention of anatomical illustration of all kinds) and accompanied by a more schematic line drawing with a key. It was certainly received as an admirable achievement of great use. The *Monthly Review* noted that 'we are at a loss whether most to admire this artist as a *dissector* or as a *painter* of animals' and recommended the work equally to gentlemen, farriers and 'horse doctors', and the eminent Dutch anatomist Petrus Camper praised him for his 'accuracy and industry ... elegancy & exactness'.[15]

The *Anatomy of the Horse* served Stubbs brilliantly in his intention of 'making himself known'.[16] From 1759 he started attracting lucrative commissions, often sporting pictures. But if the aim was to establish himself as an artist, capable of specialising in the potentially lucrative field of horse painting, it could be interpreted as an act of over-investment. A year and a half of secluded study and six or seven years single-handedly engraving the plates add up to

a long time and a lot of work. We might wonder whether Stubbs was going to special efforts to distinguish himself from his professional peers. Sporting artists were notoriously dissolute in their lifestyles, James Seymour in particular 'livd gay high and loosely – horse raceing gameing women &c country houses. never studied enough to colour or paint well' (which his surviving works make all too evident) (fig.11).[17] The aesthetic of Stubbs's plates emphasises a contrasting sense of clinical clarity, with the dissected horse hovering in the vacuum of the white page, which establishes these studies as entirely distinct from the worlds where these horses were employed and enjoyed. Yet we know that with the method of dissection described by Humphry, Stubbs had actually worked on small sections of dissection at a time, and this would have been reflected in the drawings he created. The engravers he approached in London to undertake the production of the plates were put off partly because although 'many of the drawings were of entire figures ... others were of parts only, such as Ears, Noses & Limbs', presenting a special challenge, in that the drawings could not be simply reproduced by them, but would have to be interpreted and used more creatively to generate complete, composite images for publication.[18] The great conceit of the work is to present the anatomical specimen as a totality, with no trace of the actual process of dissection remaining. And it was a sense of totality, the ability to 'comprehend the whole', as Reynolds put it in an essay of 1759, that effectively marked the launch of academic artistic idealism in Britain, which defined the true artist or true connoisseur.[19]

In London, with the drawings for the *Anatomy* in hand, Stubbs was immediately able to acquire patronage of a most distinguished kind. In 1759 he was commissioned to produce three large canvases of sporting scenes for Charles, 3rd Duke of Richmond. Still only in his twenties, the Duke had studied at the

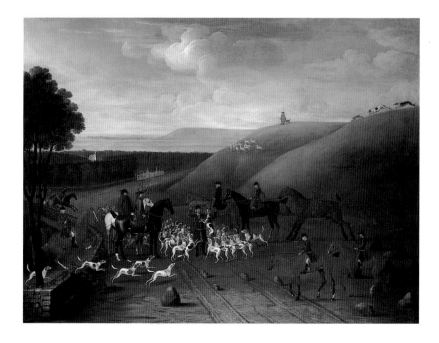

11 James Seymour
Kill at Ashdown Park
1743
Oil on canvas
180.3 × 238.8
(71 × 98)
Tate

progressive university at Leyden, been on his Grand Tour (in 1755), was a member of the scientific Royal Society, and had opened his gallery of casts after classical sculpture in London to art students. From 1758, the Society of Arts, a patriotic organisation dedicated to encouraging art, design and manufactures, which the Duke belonged to, held competitions for these students. Richmond was one of the most prominent of a new breed of cultural patrons who emerged at the end of the 1750s, who, stirred by the current wars with France, sought to establish a spirit of ambition and competition in the arts that was separated from, and sometimes in opposition to, the monarchy (the traditional source of cultural patronage).

The three works created by Stubbs for Richmond at his country seat, Goodwood House at Chichester in 1759–60, share only a little, however, of this progressive spirit. Instead, they return us to the well-established rituals of aristocratic country living. The first shows the Duke of Richmond himself, carefully positioned to be the highest figure in a gently triangular composition depicting the traditional Charlton Hunt (which dates back to the seventeenth century, and had recently been revived by the Duke). The second shows distinguished male members of the Duke's family out shooting on the estate at Goodwood. The third canvas, and generally considered the most accomplished, depicts the Duke's wife and sister accompanied by servants surveying a scene of Richmond's racing horses at exercise (fig.12). So, between them, the canvases depict landowning aristocrats and statesmen and their wives and servants out hunting, shooting and racing. In each case, the scenes are set in extensive landscapes, with the scenery of the racehorse picture stretching

12 George Stubbs *Racehorses Exercising on the Downs at Goodwood, watched by Mary Duchess of Richmond and Lady George Lennox* 1760
Oil on canvas
139.5 × 204.5 (50 × 80)
By courtesy of the Trustees of the Goodwood Collection.
Goodwood House, Chichester

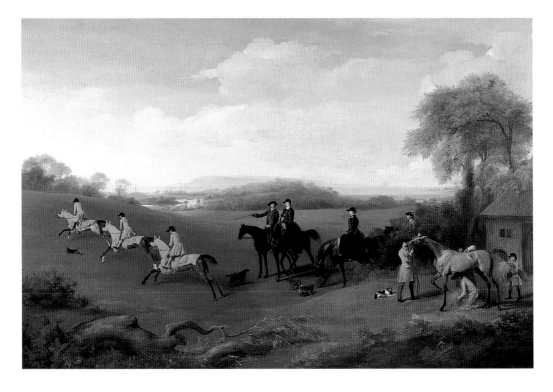

across Sussex to the Isle of Wight. They are at once enclosed and exclusive images, depicting a small circuit of family and friends participating in activities that were definitive of the aristocratic lifestyle, and expansive, relating those activities to the English landscape, both that part of the landscape owned by the people being depicted (the Goodwood Estate) and extending continuously outwards. They present a vision of the land taken, quite literally, from an aristocratic perspective, confirming the right of the landowning class to view and hold authority over the nation.

Stubbs's achievement lies in his formal management of these very substantial paintings. In the work illustrated here, the Duchess of Richmond is subtly placed at the centre, given formal distinction that confirms her social distinction within the scene. The three horses riding into the landscape are almost identical, positioned and costumed in the same way. The group of figures on the right, rubbing down a horse, are exemplary in their organised approach; each servant has a distinct task in hand, and undertakes it with complete concentration. This is an image of the world in order, formally and socially. What is odd, though, is the absence of the Duke himself in all but one of the canvases. The literal explanation is that he was occupied with military duties on the Continent, but this would require us to believe that Stubbs could not have re-used the portrait created of him for the Charlton Hunt picture, or indeed an existing portrait by someone else (Reynolds was painting him at this time). We would anticipate that a painting of a celebratory parade of racehorses would feature the owner or patron: this was the convention. In John Wootton's *George I at Newmarket* (1717) a vast racing scene had been staged so that the royal personage is positioned to oversee and hold authority over the whole, following the formal conventions of battle paintings (fig.13). Richmond was expecting from Stubbs a work that could be situated alongside tra-

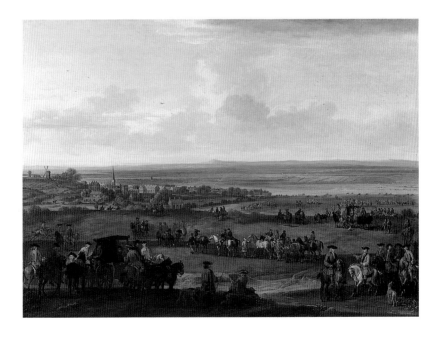

13 John Wootton
George I at Newmarket 1717
Oil on canvas
127.3 × 170.3
(50⅛ × 67)
Yale Center for British Art, New Haven

25

ditional sporting art, quite literally so, as the three canvases created in 1759–60 were originally hung alongside pictures by Wootton. It has been speculated that his unconventional absence marks the Duke's consciousness of contemporary criticism of sporting culture as reflective of a degree of corruption within the ruling classes.[20] On the one hand, these paintings are a celebration of traditional sporting values, and of the authority of the landowning class over the countryside. On the other, that issue of ownership is downplayed by the absence of the landowner himself. What draws these contradictory tendencies together is Stubbs's ability to design an image that combines tremendous formal balance with minute attention to detail, and so to present an alluring and persuasive vision of the countryside which goes beyond (even literally, in what it depicts) the bounds of the landowner's estate. These pictures mark the emergence of the way that Stubbs recreated the conventions of sporting art so that the prime point of reference is some sort of communal vision of the national landscape and rural life that was rhetorically detached from the issue of actual landownership.

This effort to aestheticise and abstract the landscape is for Stubbs, at this point, an incomplete project. These are pictures which respond to and conform to a set of specifically aristocratic ideals, and which were only meant to be seen by an audience who held those ideals. The painting of the Duke of Richmond's racehorses at exercise only hints at what was to come, and in some respects remains a clumsy picture; the recession of the three riders to the left is set awkwardly over a flattened landscape, and the head of the servant which pops up over the hedge on the right is an unintentionally comic detail. The next major commission, for a hunting picture for Lord Grosvenor,

14 George Stubbs
The Grosvenor Hunt
1762
Oil on canvas
149 × 241
(55⅝ × 94⅞)
By kind permission of Her Grace Anne, Duchess of Westminster and Her Trustees

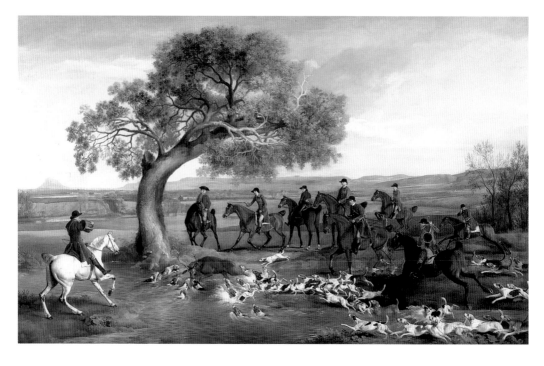

15 Peter Tillemans
Foxhunting in a
Wooded Country
*c.*1720–30
Oil on canvas
102.2 × 117.2
(40¼ × 46⅛)
Tate

shows Stubbs advancing in his formal abilities, while also presenting a still more conservative image of the landscape. *The Grosvenor Hunt* was painted for Richard Grosvenor at his country seat, Eaton Hall in Cheshire, where Stubbs went directly after completing the pictures for Richmond (fig.14). While Richmond was politically conscious and progressive, Grosvenor was a reactionary. The picture Stubbs created for him is reactionary in nature. Within a simple pictorial frame, formed by the horizon and the great curving tree to the left, the picture bustles with action, brilliantly orchestrated horses and riders and foxhounds meeting where the hunted stag collapses into the water, Grosvenor in a red coat positioned immediately above him. In its richly decorative qualities, the painting looks back to a tradition of sporting art which can be traced through Peter Tillemans to seventeenth-century Flemish models (fig.15). In its depiction of a stag hunt as a subject, the picture also looks back. This was a period when fox-hunting was becoming increasingly popular as a rural activity, while stag-hunting was becoming ever more exclusive (not least because of a shortage of stags).[21] It also had specifically royalist associations, the stag being the main sport of the legendary seventeenth-century royal hunts, an association which would have suited the anti-democratic Grosvenor well.

Within five years of arriving in London with his portfolio of anatomical drawings, Stubbs had succeeded in attracting commissions from some of the most wealthy and prominent patrons in Britain. He had transformed himself from a jobbing portrait painter, anatomist and medical illustrator into the leading sporting artist of the day, manifestly able to temper the conventions of the genre to suit his patrons' needs. But it was with the sporting pictures of the next few years that the great effort to dignify his art (expressed in the *Anatomy of the Horse*) and the need to please his patrons (expressed in the pictures for Richmond and Grosvenor) were brought together with the greatest effect and originality.

2
'A MAN WHO PAINTED RACEHORSES'

There's a man on a horse in an open landscape. He sits upright, his face turned only slightly toward the spectator, his expression impassive. He wears jockey's colours. The horse stands alert but motionless; behind is a small, anonymous brick building, and a flat stretch of land animated only by a slight frill of trees and bushes that rise on the horizon. There's a white post to the left. And that's about all.

There is not one, but two paintings by Stubbs being described here. We know that one shows the racehorse Gimcrack with the jockey John Pratt (fig.16). The horse was owned by William Wildman, a Smithfield meat trader who had risen to fame and fortune through his investments in racing. This picture is presumed to have belonged to him, and was probably commissioned after Gimcrack won for the first time at Newmarket, in April 1765. We know that the jockey is Pratt because a 1766 engraving of the painting identified him in the inscription, adding that he was the riding groom of Viscount Bolingbroke. The other picture shows a horse called Turf, owned by Bolingbroke (fig.17). We do not know who the rider is. Turf was retired when he became lame in 1767. The painting has been dated to around 1765, when he was still a winning racer.

The location of both scenes is Newmarket Heath. The brick building is one of the four 'rubbing down houses' at the racing course at Newmarket employed for wiping down sweaty horses after they had raced, using straw or cloths. Stubbs's only known pure landscapes, that is, landscapes without horses or figures, are two small studies of these buildings (fig.18). This landscape, and that blank brick building, appear a number of times in Stubbs's paintings from the 1760s. It features in a painting dated 1768, showing the horse Otho with the jockey John Larkin (fig.19). This time it is seen from a different angle, so that Newmarket itself and a church tower are visible. But the horse is again shown still and in strict profile, the jockey's impassive face turned slightly. Otho was put out to stud the year this painting was created, bringing to an end a racing career that had seen him win, in 1764, against Turf at Newmarket. He was owned by Richard Vernon, a wealthy ex-army man and Member of Parliament.

Writing about horse painting in Britain, as a specialised branch of portraiture, in 1755, the Swiss miniature painter André Rouquet stated: 'As soon as a race horse has acquired some fame, they have him immediately drawn to the life: this for the most part is a dry profile, but in other respects bearing a good resemblance; they generally clap the figure of some jockey or other upon his

Opposite above
16 George Stubbs
*Gimcrack with John Pratt Up, at Newmarket c.*1765
Oil on canvas
100.4 × 127
(39½ × 50)
Fitzwilliam Museum, Cambridge

Opposite below
17 George Stubbs
*Turf, with Jockey Up, at Newmarket c.*1765
Oil on canvas
99.1 × 124.5
(39 × 49)
Yale Center for British Art, New Haven

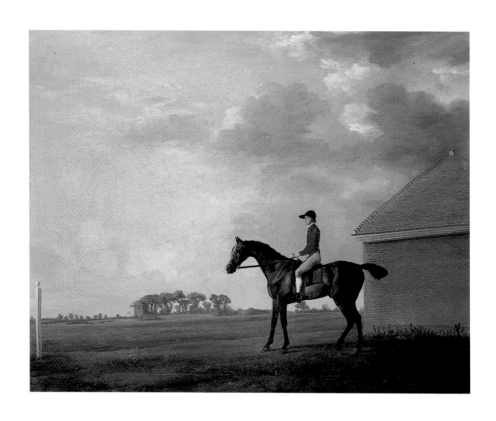

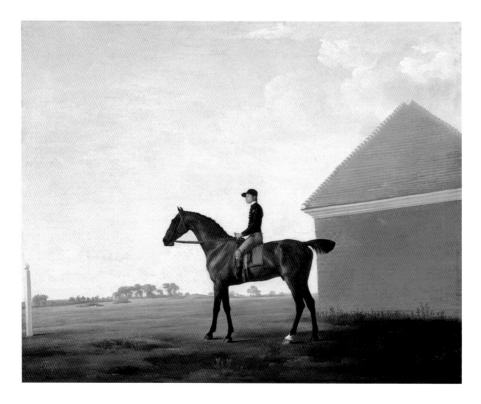

back, which is but poorly done.'[1] Rouquet could not of course be referring to Stubbs at this date: the artist was staying with his mother in Liverpool and had not yet launched himself as a sporting artist. But he is making a point about how little seems to have been demanded of horse painters from the people who tended to purchase their products. Seymour had risen to the top of his profession although he had no formal training, and unlike Stubbs, this tends to show in his pictures, which are characterised by a stiff naiveté (fig.20). And we know that around 1750 the bookseller Thomas Butler was advertising his services as, basically, a manufacturer of horse paintings: 'He and his assistants, one of which takes views and paints Landskips and figures as well as most, propose to go to several parts of the Kingdom to take Horses and Dogs, Living and Dead Game, Views of Hunts &c., in order to compose sporting pieces for curious furniture in a more elegant and newer taste than has ever been yet ... Any Nobleman's or Gentleman's own fancy will be punctually observed and their commands strictly observed.'[2]

If we were to contrive an entirely cynical viewpoint, and forget that we must assume that Stubbs is a great artist, Rouquet's description could apply to the works described above. There is the 'dry profile' of the horse, and the same formulaic positioning of the jockey. But convention has it that we must draw a sharp dividing line between Stubbs and his professional forebears. It is with Stubbs, we are told, that the formulaic and nai/ve qualities apparent in earlier sporting art are superseded. Within the artist's own lifetime, this could be

18 George Stubbs
Newmarket Heath,
with a Rubbing-Down
*House c.*1765
Oil on canvas
30.2 × 41.9
(11⅞ × 16½)
Tate

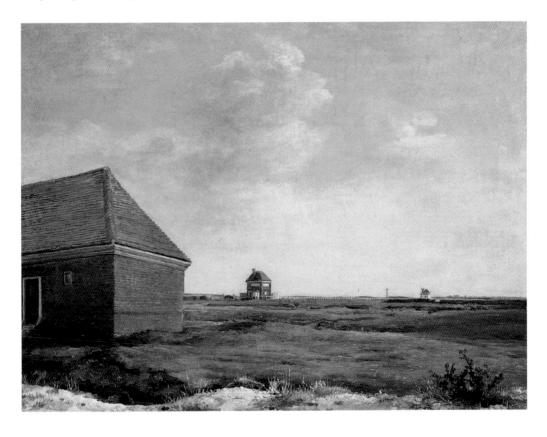

19 George Stubbs
*Otho, with John
Larkin Up* 1768
Oil on canvas
101.2 × 127
(39⅞ × 50)
Tate

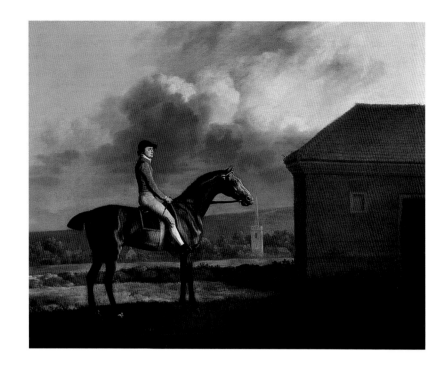

20 James Seymour
*Ashridge Bull on
Newmarket Heath
with Jockey Up*
Oil on canvas
98.5 × 124
(38¾ × 48⅞)
Private Collection

the case, so in 1796 a critic exclaimed that 'Previous to the professional ema-
nations of this gentleman [Stubbs], we were so barbarised as to regard with
pleasure the works of *Seymour*! thereby giving to what was bad, a sanction
only due to merit.'[3]

The basic parallels between any of the Newmarket pictures shown here
and one of Seymour's portraits of horse and jockey would be hard to deny.
What Stubbs did with his sporting pictures was to refine the formula. The
anatomy of the horse is much more detailed and convincing, the landscape
more fully conceived, and the slight turn given to the jockey's head provides
some sense of human character. Where Seymour sets his horse boldly at cen-
tre stage, Stubbs sets his off to one side, so its presence is dramatised by the
expanse of sky around. In every sense Stubbs's image appears more deliber-
ate, more calculated. Most of all, there is a sense that Stubbs has 'tidied up' the
horse picture, according to some hidden mathematical formula that could be
applied, with minor adjustments, time and again, for a small and tightly con-
nected clientele.

When Gimcrack won a further victory at Newmarket in July 1765, Stubbs
was again asked to produce a painting to commemorate the event, this time
for Viscount Bolingbroke who either shared ownership with Wildman or had
taken it over. This time, Stubbs created a more elaborate image, with Gimcrack
being rubbed down while the race he has just won is played out, simultane-
ously, on the right hand side of the canvas (fig.21). But the rubbing-down
house is replicated, as also the off-centre composition, the stark horizon and
the depiction of the horse in static profile. When Gimcrack changed hands
again, and was sold to Lord Grosvenor, the work was reproduced, in an exact
replica for this patron. It is with this image that the utter artifice of Stubbs's
works is revealed. For the picture is meant to depict Gimcrack after winning
the race. Yet the landscape is deserted apart from the neatly poised line of rac-
ing horses, whose presence is of course in complete defiance of the precise
naturalism the picture proclaims. We know from written accounts of horse
races of the time, and other sporting pictures, that this is far distant from the
realities of the racecourse. These were crowded, dirty, noisy places, where
people from across the social classes mixed and gambled and played. Much of

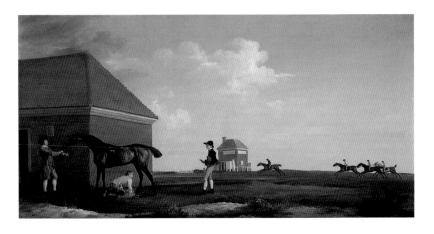

21 George Stubbs
*Gimcrack on
Newmarket Heath,
with a Trainer Jockey
and a Stable-Lad*
c.1765
Oil on canvas
101.6 × 193.2
(40 × 76)
Cottesbrooke Hall,
Northamptonshire

the appeal of horseracing seems to have been the social liberties it provided: gentlemen could parade their mistresses openly, fritter their money away, and watch and bet on boxing matches and cock fights. The normal rules that divided adult behaviour from the childish, the wealthy from the worker, were, if only temporarily and partly, dissolved in a maelstrom of rough activity. An evidently rather shocked French visitor to a race at Epsom around 1765 reported that:

> Many gentlemen of fortune ruin themselves by these pleasures ... I saw, with the utmost astonishment, how greatly the spectators of all ranks seem to interest themselves in Cock-fights, which, after all, are no more than children's play ... There are neither lists nor barriers at these races: the horses run in the midst of the crowd, who leave only a space sufficient for them to pass through; at the same time, encouraging them by gestures and loud shouts. The victor, when he has arrived at the goal, finds it a difficult matter to disengage himself from the crowd, who congratulate, caress, and embrace him, with an effusion of heart, which it is not easy to form an idea of, without having seen it.[4]

Earlier in the century, Defoe had noted the 'great concourse of nobility and gentry' that gathered at Newmarket for the races, but also reported that 'they were all so intent, so eager, so busy upon the sharping part of the sport, their wagers and bets, that to me they seemed just as so many horse-coursers in Smithfield, descending (the greatest of them) from their high dignity and quality, to picking one another's pockets'.[5] So the racecourse was something of a topsy-turvy world, where the rich acted like wide-boys or played like children, and the poor had an uncommonly good time. Together they created a scene that was in itself spectacularly unruly:

> Such galloping, such gambling, and such betting,
> Such capering, such cutting and curvetting!
> Oh, such a world of bothering and of noise.[6]

The defining quality of Stubbs's racing pictures could be said to be the complete absence of any hint of 'bothering and noise'. His is an abstracted image of the racecourse, abstracted from the realities of the race as a social event, but abstracted also in his management of a limited repertoire of elements that are rearranged repeatedly into a series of 'new' compositions which all resemble one another. What we can trace across these canvases is not really the documentation or commemoration of individual races, or even particular horses, but a celebration of the power of art to project an image of order that seems to exist above and beyond specific circumstances. It was an image that his patrons, as a class, and encompassing (a few of) the self-made men of the racecourse as well as those with inherited wealth, could subscribe to.

In that sense, Stubbs's images participate in the ordering and regulation of racing itself that emerged in this period. By the middle of the eighteenth century there was increasing concern about the unruliness and social disruption of races. A 1740 Act of Parliament was aimed at restricting the 'Excessive Increase of Horse Races' by introducing the ruling that the stake had to be a

minimum of £50 and setting minimum weights. And around 1750 the aristocratic Jockey Club was established, as a self-elected regulatory body. It introduced a system of jockeys' colours and authorised publications documenting race meetings and the genealogies of horses. The racecourse was being rationalised, at once providing more and more accurate information for the public at large, and reaffirming the authority of the aristocratic class. The race meeting might still be a rough and ready place on the day, but the principles for keeping the race itself in order were in place. With his paintings, Stubbs (many of whose patrons were members of the Jockey Club) was similarly putting his house in order. In his art, as in the printed records and rules of the races, horses were being ennobled and classified according to a highly formalised system.

The ultimate expression of this ordering tendency came with the pictures of horses Stubbs created in the 1760s where the background was absent altogether. We know that Stubbs's procedure in creating his horse subjects was to paint the horses first before 'filling in' the background. In several canvases from this period the background is left blank (fig.22). Most famous of these images is the life-size picture of *Whistlejacket* commissioned by the one of his most regular patrons, the Marquess of Rockingham (fig.23). Whistlejacket's racing career had finished in 1759; when this work was created, he was a stud horse. It is as a creature of vitality and even virility that Stubbs presents him. There is an old story that the picture was intended originally to have had George III on horseback, but that when Rockingham went into political opposition the idea was cancelled and the picture left without rider or background. There is no real evidence that this was the case, and it has been noted that

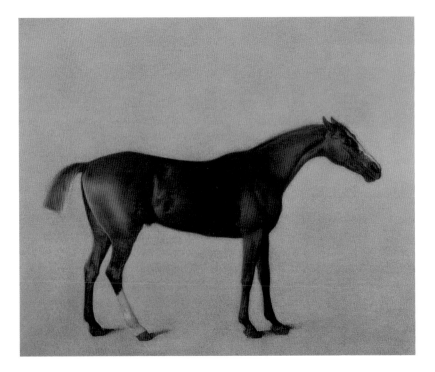

22 George Stubbs
*Eclipse c.*1770
Oil on canvas
64.8 × 78.1
(25½ × 30¾)
Gift of Paul Mellon to
the Royal Veterinary
College, London

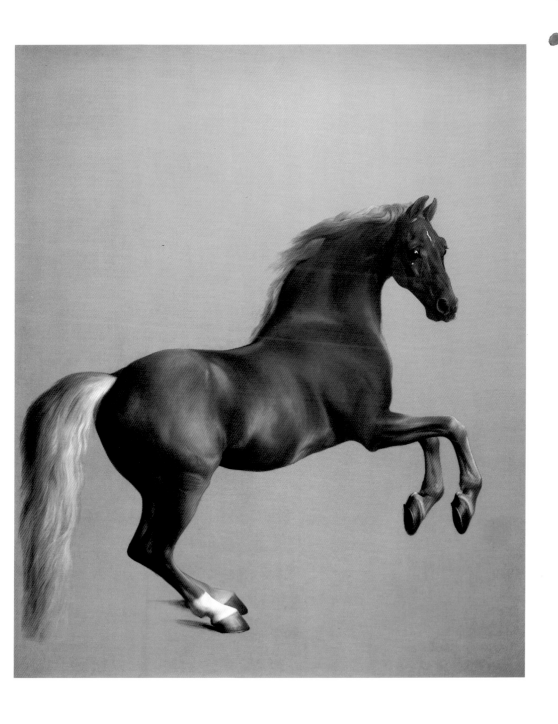

23 George Stubbs, *Whistlejacket* 1762
Oil on canvas 292 × 246.4 (115 × 96⅞)
National Gallery, London

24 Thomas Beach
Richard Tattersall
1790s
Oil on canvas
Private collection

Stubbs distorts the form of the horse for dramatic effect, leaving no room for a rider if he had wanted to introduce one. Instead, we must assume that the picture is how the patron wanted it. Without any landscape setting, without a saddle or bit, without the stable boy (who reportedly led the horse while Stubbs studied it), we are left with an animal transformed into a monument without any function other than to be admired. The horse is utterly removed from any of its actual, functional contexts (the racecourse, the stud farm) which involved the reality of social relationships and the exchange of money, and is cast instead as an art object. What Stubbs achieves is, with the greatest technical aplomb, an effect like that much more crudely sought in a later portrait of Richard Tattersall by Thomas Beach (fig.24). Tattersall was an ordinary man who rose to great wealth through horseracing, and particularly through his ownership of the horse Highflyer, after whom he named the country house he had rebuilt with the profits he made. It is Highflyer who is depicted in the painting on the wall, by John Boultbee. On the table is a sheet of paper with the words 'Highflyer not to be sold' written on it. The portrait thus at once parades Tattersall's wealth, and proudly announces that his wealth is such that he no longer needs to engage in commerce. The horse he owns had stopped being a source of income, and has become instead a painting on the wall. Property is made into art. Where Tattersall displays a degree of gaucheness in making this so explicit, Rockingham and Stubbs produced an image which so subtly conforms to sporting culture's (still current) ideal that the racehorse can be 'a symbol of power and grace' rather than 'a fragile

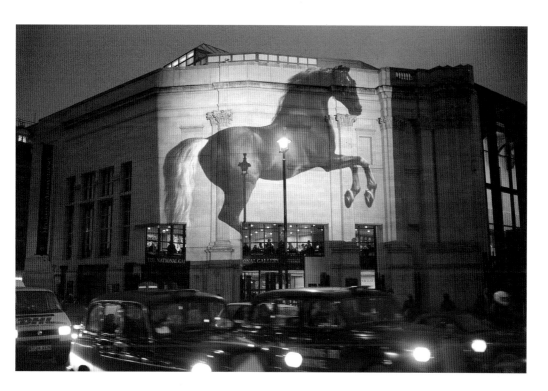

25 Photograph of
George Stubbs's
Whistlejacket
projected on to the
wall of the National
Gallery, London,
20 December 1997

26 George Stubbs,
with additions by
Joseph Vernet and
François Boucher
Hollyhock 1766
Oil on canvas
38.7 × 47.7
(15¼ × 18¾)
The Royal Collection

symbol of money' that we might find it hard to see this picture as a record of property.[7] Projected onto the exterior wall of the National Gallery during the campaign for its acquisition, the picture has been recreated as a luminous emblem of a shared national culture (fig.25).

Stubbs's refined and sophisticated formulae for recreating racehorses as symbols of grace and power did not always find favour. We know that the landscape in his portrait of the horse Hollyhock was repainted in France by Joseph Vernet and François Boucher in a style whose lurid colours and decorative qualities certainly provide more visual interest than Stubbs generally did in his backgrounds (fig.26). A running theme in press criticism of his exhibited works was his failure to create interest in his landscapes. In 1775 the *London Evening Post* (6–9 May) reported that the artist 'has displayed his usual anatomical knowledge, and soundness of painting ... It is a pity, however, that he does not pay a little more attention to his backgrounds, or, in other words, that he does not get somebody else to do them for him.' The very texture of his paintings could come under attack, as in this critical commentary of 1771:

> A painter, that introduces many horses into a picture, has an easy
> opportunity, by a judicious choice of different colours for those horses,
> of giving his pictures a considerable effect in regard to clear-obscure,
> *Stubbs* never availed himself of this. I think too that the silky pencil he
> has gives these animals an unnatural appearance; and I likewise
> apprehend that he was always apt to give his mares too thin and
> stringy a countenance; by means of which they had somewhat the air
> of stone-horses. It may further be said that, though his horses are not
> ill-coloured, they are far from having the truth of colouring or the
> roundness that we see in many of *Wouverman's*. In short, they had
> always a small matter of the coloured print: and this I take to be
> owing in some degree to his not laying a thicker body of colour where
> the strength of the light falls than in other parts.[8]

The very clarity and formality of Stubbs's horse paintings which served him so well with his sporting patrons is here dismissed by setting it against the example of the Old Masters. His slick painted surfaces did not have the texture and richness and depth that conventionally signified 'artiness' and intellectual ambition. He may have been able to produce images which conformed brilliantly to the noble and rational self-image that the aristocratic (and more rarely, non-aristocratic) horse-owners and racing enthusiasts wanted to project, but for some critics he was only a horse painter producing 'coloured prints' (and perhaps not so different from Thomas Butler, at the end of the day). In observing the demands of his patrons for an art that could celebrate their sporting activities with unprecedented dignity, Stubbs isolated himself from what was developing as a public culture for art, whose values were different from, and perhaps even antagonistic to, the traditions of aristocratic life. As we shall see, he tried again and again to re-establish himself, often to the indifference or displeasure of the critics and public. But his efforts led to the creation of some of the most original imagery in British art, imagery that remains compelling and much stranger than we realise.

'UN-NATURAL FICTIONS'

> The name of this eminent artist is familiar to few people at the present day. In some great mansions the housekeeper will pronounce it, and a visitor who catches that unknown monosyllable in the midst of her drawling roll, may glance with admiration at the big picture overhead, but will probably again forget. And in old country inns of Yorkshire, where men love the weight-carrying horse their fathers bred, you may find Stubbs's name on prints which the villagers still admire. By such works, indeed, he appears to be solely remembered among our critics. 'Stubbs?' they say – 'oh, a man who painted racehorses!'[1]

Stubbs would have been dismayed at this report, included in Joseph Mayer's *Life of George Stubbs* (1876), the first modern biographical account of the artist. Although his death was marked by laudatory obituaries, memory of the artist faded quickly. He was not included in Allan Cunningham's *Lives of the Most Eminent British Painters* (1829–33) a book that did much to establish the popular canon of British art, and Ruskin did not mention him once in all his voluminous writings on art. Well into the twentieth century he was still remembered only as a sporting artist, and therefore beyond the mainstream of British art history. The problem was pinpointed in a letter to *The Times* from 1944, when great efforts were being made to establish a national gallery of British sporting art: 'The super-highbrow art-lover and the eminent critic have seldom bestowed their blessings upon sporting pictures; seldom, too, have ardent sportsmen crowded into our picture galleries.'[2] Only after the war did Stubbs's reputation begin to be re-evaluated, and his place within art history confirmed, primarily by recovering him as 'more' than just a painter of horses (and therefore of interest only to people who liked horses, and who were thus unlikely to admire art). This was the central theme of the major exhibitions of his work held at the Whitechapel Art Gallery in 1957 and the Tate Gallery in 1984, both of which stressed his achievements in portraiture and landscape painting.

The arguments played out around Stubbs's art in the nineteenth century were current in his lifetime. The artist was all too aware that as a sporting painter he could not be as highly valued as he wanted according to what was emerging as the predominant definitions of artistic expertise. As promulgated by Reynolds and the circle of artists who were to form the Royal Academy, artists' claims to greater social status and professional recognition were tied to a conception of art modelled around the hierarchy of genres. Their proposal was that artists can and should be held in high esteem because in their engagement with the poetic imagination they shared the moral and intellectual qualities of the poet, and should be similarly valued for their contribution

to the national culture. In principle, this would mean that artists should paint poetic subjects, drawn from literature and history. In practice, few found the patronage to enable them to do this. Instead, we find, in the serious art theory and in press writing, both the affirmation of the old hierarchy of genres, and quite novel levels of attention to the formalities of imaginative painting – that is, the management of light and shade, the use of colour and painterly texture, the creation of dramatic effects – that could signify artistic ambition almost regardless of subject matter. As we have seen in the criticisms made by the writer Richard Baker, quoted at the end of the previous chapter, Stubbs was frequently seen as falling short on these counts. The calculated formality of his sporting pictures conformed to the ideals of the sporting world, but not to the expectations of the larger critical audience that was developing. He would have to go to great efforts to be taken more seriously by them.

While the bland landscape of Newmarket Heath offered few opportunities to exercise an ability to articulate a self-consciously 'artistic' sense of light and shade and texture, alongside these works the artist created more explicitly imaginative scenes. Stubbs painted a number of horse pictures where he introduced the landscape of Creswell Crags as the background (fig.27). The Crags were an isolated rocky formation on the border of Nottinghamshire and Derbyshire, on the estate of the Duke of Portland (one of Stubbs's patrons). For Stubbs, they provided an alternative means for the re-creation of the horse as an art object. With its looming height, asymmetry and rugged texture, the landscape of the Crags conformed to emerging ideals of the uncultivated landscape as a source of aesthetic and imaginative stimulation – ideals formulated

27 George Stubbs
A Grey Hunter with a Groom and a Greyhound at Creswell Crags c.1762–4
Oil on canvas
44.5 × 68
(17½ × 26¾)
Tate

by the theory of the 'picturesque'. The picturesque, as the word suggests, was concerned with the suitability of natural forms and landscapes to be viewed as 'pictures'. It was about containing (within the limits of an actual or imaginative frame) nature to make it suitable for pleasurable consumption. As deployed by Stubbs, the setting of the Crags packages the horse as a creature of wild nature, in an ancient and mysterious landscape of no clear economic purpose (this is not farmland, or a racecourse) and useful only for the pleasures of rambling and hunting hares. As much as the blank background of *Whistlejacket*, the Crags enabled Stubbs to remove his horses from the socially complex settings in which they actually served, into the realm of 'art'. In their artifice, these scenes recall the comment made by the twentieth-century sporting artist Alfred Munnings, who while admiring Stubbs's pictures would ask: 'But where can a fellow ride in such a scene?'[3]

The landscape of Creswell Crags provided the background for the most sustained series of images created by Stubbs in his effort to establish himself as a painter with imaginative as well as descriptive faculties. Starting with a huge canvas created for the Marquess of Rockingham in 1762, Stubbs created a series of paintings and prints depicting a violent encounter between a horse and a lion that stretched right through to the 1790s. It was a series intended to appeal far beyond the little network of his sporting patrons, to an audience generated after 1760 by the new art exhibitions and the print market.

The series has been grouped according to four incidents: 'A' showing the horse and lion some distance apart, with the horse gripped by fear; 'B' show-

28 George Stubbs
Horse Frightened by a Lion c.1763
Oil on canvas
70.5 × 101.9
(27¾ × 40⅛)
Tate

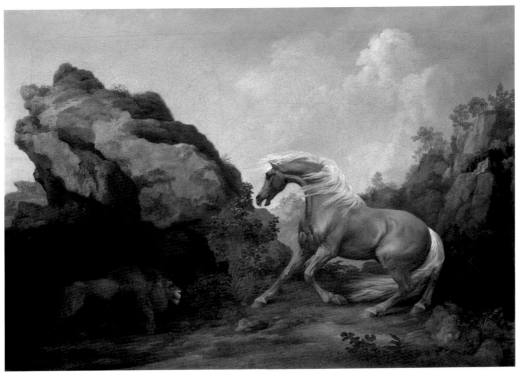

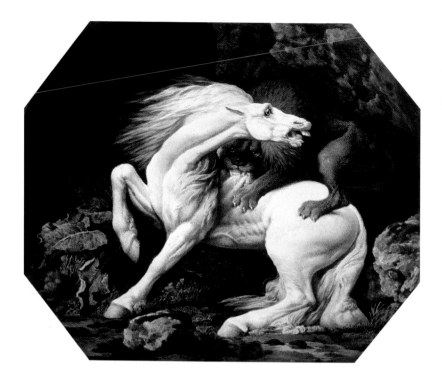

29 George Stubbs
*Lion Attacking a
Horse* 1769
Enamel on copper
24.3 × 28.2
(9⅝ × 11⅛)
Tate

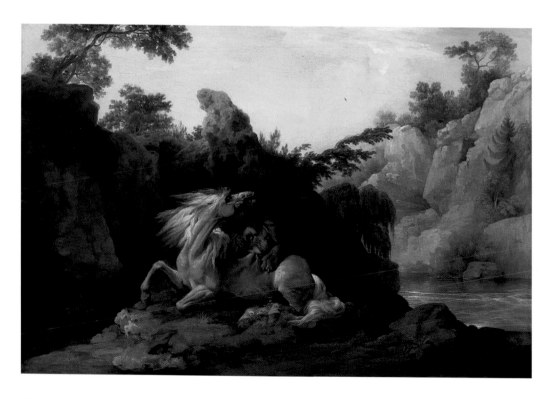

ing the horse recoiling from the lion (fig.28); 'C' depicting the attack itself (fig.29), and 'D' where the horse collapses under the weight of its attacker (fig.30).[4] Stubbs took his inspiration for the series from the ancient sculpture in the gardens of the Palazzo dei Conservatori on the Capitolene in Rome. While it is entirely likely that Stubbs would have seen this work during his brief time in the city, the work he would have seen there had been restored in 1594 so that the horse's head looked downwards. Where it resembles the ancient group most closely, the composition developed by Stubbs shows the horse looking back at the lion, the position the ancient sculpture depicted before restoration. In its pre-restoration form, the group had been engraved and interpreted in bronze sculptures, versions of which may well have been owned by Stubbs's patrons. It is more likely one of these sources, rather than the experience of seeing the original sculpture, that Stubbs was actually referring to. There is also the story deriving from an early account of the artist's life that he saw a real scene of a lion fighting with a horse in Morocco, when he was returning from Italy. But such a visit would have been extremely unusual in the eighteenth century, and there was no need to go to Africa to see a lion. When Stubbs did observe a living lion, it was in the less exotic setting of the menagerie of his patron Lord Shelburne at Hounslow Heath. His drawings show this animal looking considerably more grumpy and tired than any of the creatures in the 'Lion and Horse' series, as he might well do caged in England.

With versions of the subject exhibited by Stubbs with the Society of Artists in 1763, 1764, 1768 and 1770, the publication of prints after his paintings (fig.31), his design of a version of the theme for ceramic plaques created by Wedgwood (fig.32), and the subsequent incorporation of the motifs into decorative wares by manufacturers, the 'Lion and Horse' was the most extensive, and popular, of Stubbs's series. Together with a more disparate group of pictures of lions and 'tygers' (a term used rather indiscriminately at the time to describe what we would call leopards, as well as tigers) in paint and print (fig.33), these wild creatures in wild settings were equal to sporting subjects in Stubbs's presentation of himself to his public.

With their raging action and dramatic landscape settings the 'Lion and Horse' pictures were images calculated to appeal to the contemporary taste for the 'sublime' in art. As codified by Edmund Burke in his *A Philosophical Enquiry into Our Ideas of the Sublime and the Beautiful* (1757) and a host of essayists and philosophical writers, the theory of the sublime was concerned with the pleasures taken in the feelings of fear, shock and horror arising from the encounter with objects and events that were dark, massive or sudden. Sublime themes, involving drama and darkness and shock effects, occupied an important place in late eighteenth-century art, stimulating the creation of awesome landscapes and hysterically overblown theatrical and literary subjects. Such sublime imagery helped bridge the gap between the idealist art proposed by elevated art theory, and the more basic tastes of the vast majority of the public. It provided the emotional, sensual and intellectual thrill that was traditionally associated with the more exclusive subject matter derived from epic poetry, but served up in a fashion that could ensure instantaneous gratification from a wider art public that was not familiar with those sources.

30 George Stubbs
Horse Devoured by a Lion c.1763
Oil on canvas
69.2 × 103.5
(27¼ × 40¾)
Tate

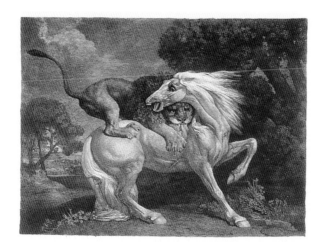

31 George Stubbs
*Horse Attacked by a
Lion* 1788
Print. Soft ground
etching and roulette
work on paper
25 × 33.5
(9⅞ × 13⅛)
Tate

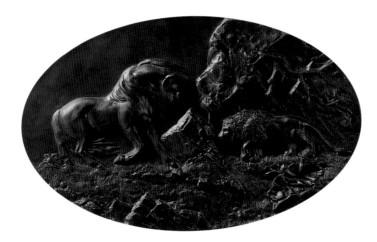

32 After George
Stubbs
*Horse Frightened by
the Lion* 19th century
(after 18th century
original)
Black Basalt
36.8 × 22.9
(14½ × 9) oval
The Wedgewood
Museum

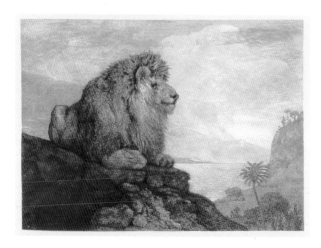

33 George Stubbs
Lion Resting on a Rock
1788
Print (mixed method
engraving on paper)
22.7 × 31.4
(9 × 12⅜)
Tate

Stubbs's treatments of the 'Lion and Horse' theme were received in exactly these terms. As the high-minded history painter James Barry said in response to one of Stubbs's paintings of a horse and lion, it 'must rouse and agitate the most inattentive'.[5] And the theme of Horace Walpole's poetic account inspired by seeing his startled horse at the Society of Artists in 1763, was the stimulating effects of the picture:

> Did ever terror through the senses look
> With more astonish'd force – fling down thy book,
> Vain Man![6]

So according to Walpole, Stubbs's picture could stir the viewer from his introspective, bookish lifestyle. The non-specific settings, the looming darkness that often surrounds the animals, the taut, focused compositions which always draw the eye into the physical or visual contact between the animals, combine to create images of startlingly instant visual effect. While it is possible to reconstruct some sort of narrative sequence for the 'Lion and Horse' theme, Stubbs did not follow this in the way he produced these images, exhibiting and publishing pictures with no attention to any kind of narrative sense. The point of the series is not to maintain a narrative sequence but in each case to provide in a single image a moment of drama that does not need to be informed by the viewer's knowledge of literature, or a specific landscape, or any kind of story. If, with the art exhibitions and the burgeoning market for prints, this is the moment when British art joined the emergence of a consumer culture, Stubbs's 'Lion and Horse' pictures were a kind of fast food.

The thrill provided by the 'Lion and Horse' pictures found an analogy in real life. There were a host of menageries in London where people could see for themselves exotic and wild animals. As a breathless tourist reported in 1773, you could see 'Wild Beasts in every Street in Town'.[7] The arrival of new animals in the country was the occasion for tremendous public interest. When the first zebra arrived in England in 1762 and was put on show at Buckingham House before touring the country, Stubbs painted its picture and exhibited it at the Society of Artists (fig.34). When the first moose arrived from Canada in 1770, William Hunter commissioned him to paint that as well to demonstrate the distinctness of this species from the extinct Irish elk (the antlers of which are introduced at the left of the canvas to make the point) (fig.35); then, later, his brother John commissioned a picture of the yak which had arrived in London (fig.36). And when an attempt was made in Windsor Great Park to discover how cheetahs hunt by setting a real cheetah loose on a stag, Stubbs was commissioned by its owner to paint a portrait of the animal. The experiment failed miserably, but Stubbs presented a typically dignified image of the animal, complete with exotically costumed handlers and curiously contrived landscape that tries to be both India and the Home Counties (fig.37). The thrill of the exotic stretched across and brought together the worlds of popular street shows, serious science and the more trite kind of sportsman's entertainment, parading as an experiment in natural history. Stubbs's art could operate equally in each context; removed from the context of their creation, each of these images can be admired in the same way, for their remarkable

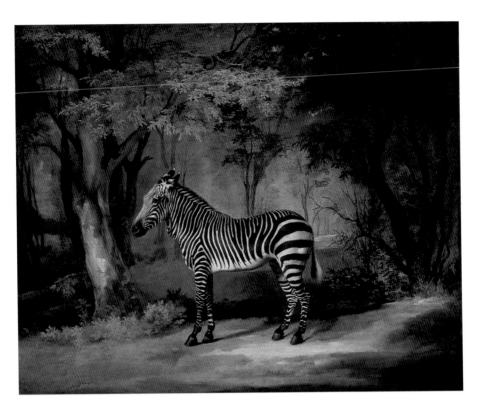

34 George Stubbs
Zebra 1763
Oil on canvas
103 × 127.5
(40⅝ × 50¼)
Yale Center for
British Art, New
Haven

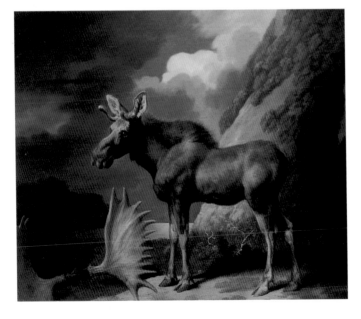

35 George Stubbs
*The Duke of
Richmond's First Bull
Moose* 1770
Oil on canvas
61 × 70.5
(24 × 27¾)
The Hunterian Art
Gallery, University of
Glasgow

36 George Stubbs
Yak (Nylghau) 1791
Oil on canvas
The Royal College of
Surgeons, London

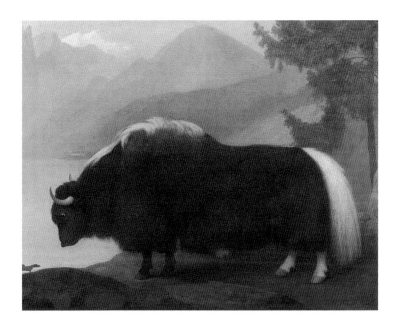

37 George Stubbs
*Cheetah and Stag with
Two Indians* 1765
Oil on canvas
180.7 × 273.3
(71⅛ × 107½)
City of Manchester
Art Galleries

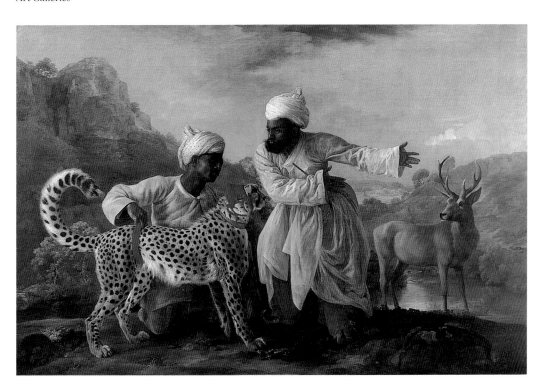

attention to the specificities of colour and texture and physical structure, their ability to monumentalise these creatures, and to create an evocative natural context for them. In each case Stubbs's ability to create an image of factuality, which disqualified him from consideration as a serious artist, is brought into service in the transformation of nature into a visual spectacle. The culture of Enlightenment, with its desire to identify, classify and reveal, was also a culture of commodification.

In his 'sublime' imagery of horses and wild animals, and his depictions of exotic creatures, Stubbs participated in a visual culture of novelty that encompassed the adventurously imaginative paintings of Henry Fuseli, the scenes of Vesuvius erupting created by Joseph Wright of Derby, and the views of the Indian landscape and lifestyle that were being produced in print and exhibited at the Academy. Observation and wild speculation were two sides of the same coin, each feeding a demand for spectacle that was emerging as a defining characteristic of modern culture. Stubbs can, though, be distinguished from his peers in extending this search for novelty into the very painting techniques he employed, with his experimental use of enamels and ceramic supports.

According to Humphry's *Memoir*, Stubbs's friend, the successful and fashionable miniature painter Richard Cosway, suggested that he experiment in the medium of enamel. While known to be far more durable than oil painting, enamel painting (in which colours are applied to a heat-proof surface and put into a fire which causes them to fuse into a solid surface) had only ever been employed for miniatures or small-scale decorative objects. However, the desire to experiment with hardier alternatives to oil painting was not new. The French writer the Comte de Caylus had published on 'encaustic painting' in the 1760s, and Horace Walpole had taken a German artist called Muntz into his house to try out different methods of painting in enamel. Academic literature stressed the supreme value of fresco painting, over the relatively fragile and fugitive qualities of oil painting. Indeed, oil paint itself, with its mucous, malleable nature, had associations with sensuality and corrupt modernity. The greatest art, the art of the ancients and of the Renaissance masters, was undertaken in media which both demanded exacting technical skill in drawing and ensured permanency. A recurring theme of late eighteenth-century cultural criticism is the decline that accompanied the creation of private, transitory, sensual art; the great artist of today should strive to rise above history.

So despite the unconventional nature of Stubbs's experiments, which brought him into close association with the cutting-edge of commercial, industrial science, and the unusual single-mindedness with which he pursued them, in attempting to create enamel painting the artist was participating in what was proclaimed by academic art theory to be one of the central endeavours of modern British art. The first phase of Stubbs's experimentation lasted from 1768 to 1775.[8] During this period he attempted enamel painting on copper. Seven examples survive, including an extremely compact version of his 'Lion and Horse' theme, and the *Mother and Child* (figs.29, 6). None were depictions of racing horses, highlighting how this technical experimentation was an extension of Stubbs's aim to demonstrate his abilities across a range of

38 George Stubbs
Josiah Wedgwood
1780
Enamel on
Wedgwood biscuit
earthenware plaque
50.8 × 40 6
(20 × 16) oval
The Wedgwood
Museum, Barlaston

genres. The enamels were, accordingly, given public exposure. One of the very first enamel pictures, the *Lion and Stag*, was engraved by George Townley Stubbs, and a proof of the print was displayed in the 1770 Society of Artists' exhibition. The 'Lion and Horse' on copper was exhibited in 1771, and the companion piece to the *Mother and Child*, *Hope Nursing Love*, in 1772. But we only know of one of the enamels – the exhibited 'Lion and Horse' – being sold during Stubbs's lifetime, and in 1775 Stubbs stopped producing enamels on copper, his last work in that medium being a version of his *Phaeton and the Chariot of the Sun* (fig.41). Despite his best efforts, enamelled copper plates could only be created on a relatively small scale; the final *Phaeton* copper is the largest of all, and is still only 46cm wide. In his search for an alternative, he approached Eleanor Coade, who successfully manufactured sculptures, architectural fittings, and even some pieces of furniture, in an artificial stone. But this liaison seems to have come to nothing, and the support of only one of his enamel paintings has been attributed to Coade, and that only tentatively. Far more fruitful, though, was his association with Josiah Wedgwood.[9]

Wedgwood was a pivotal figure in the modernisation of British industry. His introduction of standardised pottery designs and the technical means of replicating those designs in large volumes revolutionised the industry; his innovative marketing techniques revolutionised taste. Among his innovations was the employment of artists on projects, as much for the prestige they brought to the firm as for their designs. So when Stubbs approached him in 1775 with the idea of creating ceramic supports for paintings, the manufac-

turer must have been aware not only of the business opportunities were he to succeed, but the possible publicity even if he were not. The first practical attempts to create ceramic supports appear to have been in 1777, when Wedgwood reported that 'We have fired 3 tablets at different times for Mr Stubs, one of which is perfect, the other two are crack'd & broke all to pieces.'[10] Hardly a great success rate, but these tablets were already larger than the largest of the copper-plates Stubbs had used as a support for his enamel painting. Things progressed slowly through 1778 and 1779, but by the end of the latter year Wedgwood was hopeful that he could create a support as large as 90cm across. In the following year, Stubbs went to stay with Wedgwood at his headquarters, Etruria, in Staffordshire. His main purpose was to paint portraits of individual members of the Wedgwood family, some on Wedgwood plaques, and a group portrait of the Wedgwoods gathered in the grounds of Etruria with Josiah's favourite pot from his manufactory ('No.1' in his book of designs) prominently sitting on a table by his side (figs. 38, 39). While Wedgwood was initially sympathetic to Stubbs's desire to expand his practice, he was disappointed by the results. In October, when Stubbs thought the group portrait was almost finished, Wedgwood wrote: 'I think he is not quite so near a finish as he seems to apprehend ... some parts are either a little caricatured, or my own eyes and those of many of my friends are much deceived ... we are all heartily tired of the business, and I think the painter has more reason than any of us to be so ...'[11] The experiments with the plaques continued, nonetheless, with enamels on the larger-size supports promised by Wedgwood being exhibited by Stubbs at the Academy in 1781 and 1782, including the unusual *The Farmer's Wife and Raven* based on one of John Gay's poetic 'Fables' (fig.40).

39 George Stubbs
The Wedgwood Family
1780
Oil on panel
47.5 × 59.5
(18¾ × 23⅜)
The Wedgwood
Museum, Barlaston

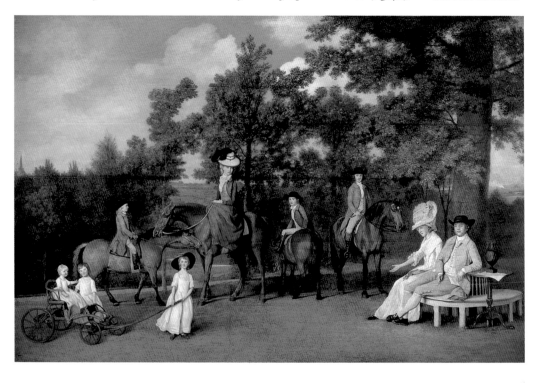

40 George Stubbs
*The Farmer's Wife
with the Raven* 1782
Enamel on
Wedgwood biscuit
earthenware
27.5 × 37
(10⅞ × 14⅝)
Board of Trustees
of the National
Museums and
Galleries on
Merseyside (Lady
Lever Art Gallery)

But after disastrous attempts to produce larger plaques in 1783, the effort was abandoned, and Stubbs returned to Wedgwood supports only briefly, more than a decade later.

The exhibited enamels were generally quite well received, if only for the novelty of the technique. If these experiments were Stubbs's attempt to establish himself as an artist striving for immortality, rather than just a horse painter tied to the immediate pleasures of the sporting world, his efforts found some support. A critic in the *Morning Chronicle* (5 May 1781) admired them in terms which registered the artist's aspirations; he wrote that the enamels 'are like the works of a gentleman, *masterly*, and what pleasure the *fire* has taken from the present age, in making Parts *woolly*, it will render to posterity in giving them a glimpse of the works of this artist'.

On a few occasions Stubbs took a more conventional route to presenting himself as an artistic 'gentleman', with the creation of paintings based on elevated literary sources. We know that he created a series of large-scale paintings depicting Hercules, one of which was exhibited at the Society of Artists as early as 1770. These were still known at the end of the nineteenth century but are now lost. We do, though, have two versions of his composition of the classical subject, *Phaeton and the Chariot of the Sun*. The first, oil-painted version of the subject, was included among the four pictures shown by Stubbs with the Society of Artists in 1762, and was subsequently owned by Reynolds and then John Parker of Saltram, Devon (fig.41). There is also a second version on the largest of the copper plates he ever used as a support. Stubbs was so proud of this work that he had it included in the portrait of him by Ozias Humphry (frontispiece). There is at least one further version of the subject by Stubbs which has been lost, and possibly more. Additionally, in 1780 the design was reproduced, rather reluctantly, by Wedgwood as a plaque to partner the *Horse Frightened by a Lion* (fig.32). The potter objected that while the frightened horse Stubbs had already designed for him was 'a piece of natural history' the Phaeton would be 'a piece of un-natural fiction & indeed I would prefer something less hackneyed'.[12]

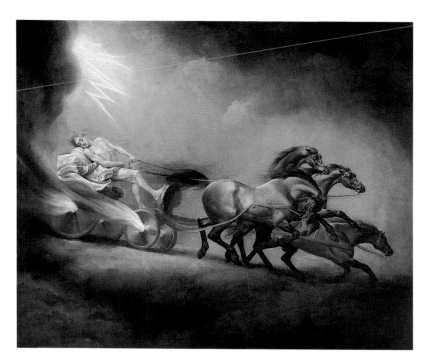

41 George Stubbs
*Phaeton and the
Chariot of the Sun*
1762
Oil on canvas
99 × 122 (39 × 48)
The Morley
Collection, Saltram.
The National Trust

The picture shows Phaeton, son of Apollo, plunging to his death in his father's chariot, a story taken from Ovid's *Metamorphosis*. Ovid was a standard source of subjects for history painting, though this subject had not before been attempted in British art. Although clearly an attempt to conform to academic principles, in taking an epic subject from ancient myth that was irrefutably a work of imagination rather than mere description, the subject was not such a dramatic departure for him: it meant that he was able to exercise his established skills, with the horses said to have been modelled on Lord Grosvenor's coach-horses.[13] Also, such classical subjects were not entirely distinct from sporting culture. Many famous horses were named after classical figures, and in sporting literature a particular racehorse might be praised by comparing him to Samson or Hercules.[14] A version of Stubbs's subject even appeared as a marginal illustration to a little collection of prints documenting great racing horses published in the 1760s, reincorporating it into the sporting culture he was trying to escape from (fig.42).

Wedgwood was far from alone in viewing suspiciously Stubbs's attempts to move outside of descriptive animal painting. In 1767, when he was rumoured to be turning to portraiture, an otherwise admiring critic damned the effort as mere vanity:

> But why to Portraits should his Genius stoop,
> And turn his back upon the fav'rite groupe;
> Dismount inglorious from the stately steed?
> Relapse to Portraits makes me smile indeed!
> How love of Fame its ardent thirst displays,
> No appetite so keen as that of praise.[15]

Comments like this appear quite frequently in the newspapers and reviews, the equestrian analogy being continued in comments instructing the artist 'not to forsake the *Stable*' or 'quit his horse for a hobby-horse'.[16] Stubbs tried hard and in a number of different ways to establish himself as something other than 'horse-painter'. The rewards were not too great, and while the wild animal subjects and non-sporting scenes he produced dominated his output of prints, we know that even these did not sell well. Today the 'Lion and Horse' subjects and the exotic animals are among the most popular of his images. Their exotic appeal continues without their original, more charged contexts of the artist's ambitions, his patrons' needs, the culture which demanded new sensations and novelty. The prints that never sold are appreciated for their technical innovation and the experiments on copper and ceramic, which failed to work as well as they should have done, examined as highly original artistic contributions to the Industrial Revolution. We like the idea that we can see in these works things that his contemporaries could not; it is one of the ways that his authenticity as an artist is demonstrated to us. Among these efforts to diversify and re-establish himself as an artist should be included Stubbs's forays into rural genre painting. But the modern-day recovery of these works as his defining masterpieces is a subject of much greater interest in itself. It is there that the fraught politics around his art and his image of England are revealed most fully.

42 *The Portraiture of Lamprie* from *The Sportsman's Pocket Companion* 1760s, pl.8
British Library

4

'A COUNTRY BOY AT HEART'

In 1977, the year of the Queen's Jubilee and the Sex Pistols' 'God Save the Queen', Stubbs's partner pictures *Haymakers* and *Reapers* of 1785 were put up for sale (figs.43, 44). Although known to have been exhibited at the Royal Academy in 1786, and presumed to have been in the artist's studio sale, their early history was otherwise mysterious. Untracked until the 1930s, the pictures passed through the hands of dealers until being purchased by a forebear of the then current owner. In a special arrangement, this owner generously agreed to make the works available to the Tate Gallery at a price of £774,000, considerably less than the pictures were expected to fetch if they went on the open market. The catch was that the Gallery had to raise this total amount by Christmas, or the pictures would go to auction with the potential outcome that they would go to a foreign buyer. In July 1977 the Tate announced an exceptional campaign to raise these funds. The centrepiece was a lottery, made possible by recent changes in the law, and organised by the Friends of the Tate Gallery on behalf of the Trustees. At the beginning of the campaign it was announced that the main prize would be a new Mini donated by Algy Cluff, Managing Director of a small private oil company. Additional prizes were donated by a number of British companies, including Wedgwood china, vouchers for the supermarket chains Marks & Spencer and Sainsbury's, penthouse accommodation at a Portman Hotel, and an electric typewriter given by British Olivetti Ltd. A second lottery was set up by Tate Gallery Publishing, with the main prize another Mini (donated by the Lex Service Group).

With the Mini (number plate: "WIN 1") parked within the Tate Gallery (fig.45), and the lottery prizes proliferating, the campaign got saturation coverage in the national papers, and across local and specialist papers. There was some grumbling about the campaign, the odd comment that this was crassly commercial and not something a national gallery should be involving itself with. The Tate's director, Norman Reid, acknowledged in an interview on BBC Radio 4 at the very beginning of the campaign (2 August) that raising funds in the current climate was not easy, especially as Christmas was approaching and it was 'the end of the Jubilee Year', but the reality of the current economic depression and industrial unrest was left out of the discussion almost entirely. The *Sunday Mail* (14 August) struck a rare note of dissent, pointing out that 'kidney machines' are more important than art 'in these stringent times'.

Extra fund-raising efforts were put in motion. There was an essay-writing competition for children, a spot-the-detail competition, a crossword, a Christmas tombola, and special fund-raising auctions. The blurb accompanying the crossword promised that 'every penny' would go toward the acquisition of the

Opposite above
43 George Stubbs
Haymakers 1785
Oil on panel
90.2 × 137.2
(35½ × 54)
Tate

Opposite below
44 George Stubbs
Reapers 1785
Oil on panel
90.2 × 137.2
(35½ × 54)
Tate

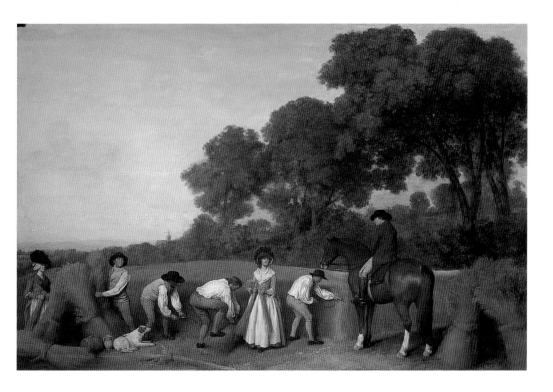

45 Photograph of the Mini which could be won in the 'Save the Stubbs' lottery, parked in the Tate Gallery/Tate Britain
Tate Archive

Solve the Crossword & Save the Stubbs

George Stubbs's 'Haymakers' and 'Reapers' of 1785 are two of his most outstanding paintings and his rare representations of harvest scenes have a very special place among his works.
The Tate Gallery has been given until Christmas to raise the £140,000 needed to complete the full price of £774,000. The Government has promised to double every contribution, and the opportunity to acquire these masterpieces for the nation must not be missed. The proceeds from this competition will go towards the Stubbs Appeal.

How to enter please read the Conditions of Entry

1
Solve the clues below and fill in your answers on the crossword puzzle in ink or ball pen.

2.
Complete the sentence about saving the Stubbs's paintings in the space provided.

3
Fill in your name and address and return the entry form **with a cheque or postal order for 50p** made out to 'Stubbs Appeal' to : Stubbs Crossword, Tate Gallery, Millbank, London SW1P 4RG.

Clues across

4 'The . . .', field of sport dealt with in a number of paintings by Stubbs (4)
7 Stubbs's masterpiece depicting farm workers (9)
9 The shin-bone (5)
10 Like a scene of happy rusticity (7)
13 Wild animals shown 'at Play' by Stubbs (8)
16 Usual surface for oil-painting (6)
17 Experience anew (6)
18 Young hares (8)
22 One of Stubbs's rare representations of harvesting subjects (7)
24 'Gimcrack with a . . .', great racing picture by Stubbs (5)
25 In 1772, Stubbs became that of the Society of Artists (9)
26 That of Stubbs's birth was 1724 (4)

Clues down

1 'A Hound and a Bitch in a . . .', by Stubbs at the Tate (9)
2 Forename of Gauguin (4)
3 Even 50 of these will help buy a Stubbs for the nation (5)
5 Earthy mineral used as a pigment (5)
6 'Mares and . . .', among Stubbs's informal groups of animals (5)
8 Come to a halt (4)
11 Famous Paris art gallery (6)
12 Fugitives from Pandora's Box ? (4)
14 Stubbs painted a 'Mother with her Infant . . .', (6)
15 A Stubbs picture of 'A Lion . . . a Horse' was described by Horace Walpole as 'very pretty' (9)
17 Flower of which 'Peace' is a favourite variety (4)
18 Like '6 Down', characteristically (5)
19 Stringed musical instrument (5)
20 Part of the anatomy of the horse, etc. (4)
21 Chestnuts, maybe, but not horses (5)
23 Chemical used to eat out the lines in etching (4)

Devised by Morley Adams Ltd

46 'Solve the Crossword and Save the Stubbs'
Tate Archive

paintings, and invited the reader to come and see the paintings on display at the Gallery (fig.46). The crossword included a self-referential clue, 3 down: 'Even 50 of these will help buy a Stubbs for the nation (5)' (Pence). With the additional test of requiring the entrant to describe in fifteen words or less why the pictures should be saved, the crossword exemplifies the way the campaign was set up to be participatory: it was meant to give each individual supporter a sense of involvement, even to the extent of filling in a crossword with the name of the currency they would be contributing.

With the Heritage Lottery Fund drawing financial support for cultural and sporting institutions from the monies garnered by sale of National Lottery Tickets, this is a model of cultural participation which has in Britain been formalised, nationalised and familiarised. Detached from specific fund-raising issues, the funds administered from the HLF can represent a 'national' resource, whose management is rhetorically removed from specific causes. From a contemporary perspective, the 1977 campaign would appear to mark firmly the movement of cultural patronage away from identifiable state authorities to a more abstract and elusive mock-public formed by the aggregation of private interests (winning a Mini, or, now, becoming a millionaire). But in 1977 the lottery and competitions were directed toward a specified end, and the rhetoric which surrounded and defined the project went beyond a more abstract definition of national culture to involve the particular qualities of the works in question. Stubbs's art was represented as embodying this model of participation aesthetically: the very form of the *Haymakers* and *Reapers* was recruited to the argument for their preservation within a national British collection.

A recurring theme in the commentaries on *Haymakers* and *Reapers* from this time is their democratic and realistic vision of countryside labour. Richard Cork in the *Guardian* (8 August 1977) argued for seeing the works as 'radical' in transcending pat clichés about country life. Judy Egerton, in a catalogue that accompanied a special auction in support of the campaign, insisted: 'Stubbs regards them [the workers] seriously, even tenderly, but seeks neither to romanticise them nor to ennoble them. Instead he represents them as if they, in their various ways, were working with the same seriousness of purpose and steadiness of effort as he himself worked all his life. Work viewed in such a light has its own dignity, which needs neither sentimentality nor drama to exalt it. Stubbs's "Haymakers" and "Reapers" are not heroes or heroines; but they are the people of England, and we must keep them here.'[1] In arguing this, there is a collapsing together of artist, subject and nation into a single image of labour – referring to the notion of industry as a national characteristic, '*the* distinguishing quality of our nation'.[2]

On 15 December 1977 it could be reported at the Trustees' Meeting that the lottery had been drawn, the full sum had been achieved, and the pictures were saved. The Gallery organised a special display of eighteenth- and nineteenth-century agricultural scenes, 'All is safely gathered in', as a means of thanking all the supporters of the campaign, showing off the newly-acquired paintings, and 'to focus on the special qualities' of those works 'by showing them with examples of other British painters' treatment of similar subjects, in most of

which the representation of actual work is incidental to the painter's feeling for landscape or mood', putting to the fore Stubbs's supposedly realistic treatment of rural labour.[3] This, again, elicited commentary on the purported democratic qualities of the picture: Stubbs was 'very egalitarian in terms of how he looked at things, how he observed things and he didn't particularly distinguish between the small flowers growing by the side of the hedgerow and the horse he was commissioned to paint ... a tremendously democratic artist who is prepared to accept the workers on their own terms'.[4]

The idea of Stubbs as labourer was an old one, as we have seen (see above, 'Introduction'). The notion that the artist's formal approach created a democratic quality was just as old, in contemporary criticism operating around his equitable treatment of all the elements which in academic theory should have been ordered and ranked according to aesthetic importance: 'His Skies, his Rocks see mark'd with equal Force, | That Strike as strongly as his Startled Horse ...'.[5] But if the 'Save the Stubbs' campaign of 1977 was a moment of emphatic clarification in the modern view of his art, there was hardly any reference to the historical reception of the paintings. Indeed, there hardly could have been, for, as we will see, they were originally received as aberrations hardly worth consideration as art. The campaign helped establish a template for press commentaries on the artist when he again rose to public attention with the 1984 Tate Gallery exhibition. The tone of those commentaries was neatly distilled by the *Sunday Times* (20–26 October 1984) in its brief notice of the exhibition: 'Although in those days everyone knew their place, Stubbs has a skilful way of giving aristocrats, peasants and creatures equality under the sky.'

Looking back on the campaign, the Gallery acknowledged that the response from industry and commerce 'was a little disappointing; no doubt the economic situation of the country was partly to blame', but 'the most revealing feature of the Appeal campaign was the overwhelming response from private individuals from all over Great Britain and Commonwealth countries. It became evident that there was extraordinarily strong support for these paintings which, apart from their sheer quality, seemed to be everyone's idea of how they felt about England.'[6] This comment aside, there was really nothing (apart from the *Sunday Mail*'s heretical questioning of the campaign itself) that acknowledged any sort of relationship between these works and the economic and social conditions of modern Britain. Nothing, that is, from the curators and art historians and journalists who shared a numbing rhetoric of patriotic celebration. But the *Evening Standard*'s essay competition elicited a response from one Daniel Bennett (aged seven and a half) of North London of an honesty not found anywhere else. This remarkably eloquent statement, decorated with marginal pastoral motifs of almost Blakean delicacy, was the only piece of text created in response to the campaign that actually, frankly addressed the appeal of the pictures (fig.47). In 1977, the year of the Jubilee and of the Sex Pistols' 'God Save the Queen', it was left to a small boy to say something honest about Stubbs, something specific and personal that didn't need to be shrouded in claims to art-historical 'truth', or muffled by abstract aesthetic rhetoric, or subsumed to an appeal to the elusive essence of mythic Englishness.

47 Daniel Bennett
When I look out of my window ... 1977
Felt tip on paper
Tate Archive

When I look out of my window I see boRing cars and I hear horrible PoP music from Addington mansions. In my head I am a town Boy because that is what I know. I see houses like walls on the sides of the Road. But when I look at this Picture I am sure that in my heart I am a country Boy. I think George Stubbs was a country Boy in His Heart But also a famous Painter And He liked Painting tree's And fields And Animals and the PeoPPle of the farms and field's. there is a feeling of Joy and happiness. when I grow up I'd like to be an Artist with about the same feeling; I would be so happy to live in the country. I'd buy a spaniel and Paint all the flowers And tree's and hills in my Heart. by DANiel Bennet Age 7 And a Half

For all the refinement and erudition displayed by the critics and curators in reference to Stubbs's pictures, Daniel Bennett may have been closest to recognising the artist's intentions. The pictures were Stubbs's sole exhibits at the Royal Academy in 1786, the first of the artist's works to be shown with the institution since 1782 (when he argued with the institution and failed to receive his academic Diploma). He exhibited them again, at the exhibition held in Liverpool by the Society for Promoting Painting and Design in 1787, and in

1788 the artist announced that the subjects would be among a group of new prints he was planning to publish. These prints were eventually issued in 1791, and in 1794–5 he repeated the subjects in three oval enamel paintings (*Haymakers* and *Haycarting*, now in the Lady Lever Art Gallery, and *Reapers*, now in the Yale Center for British Art, New Haven). They were not his first attempts at depicting the rural scene. The panels were a reworking and elaboration of a pair of images of the same subjects created in 1783, and the subjects are mentioned among the many lost drawings in Stubbs's posthumous sale. He had also painted a scene in oil of labourers loading a cart with bricks on the country estate of Lord Torrington, for Torrington in 1767, and then in enamel on a Wedgwood plaque in 1781. Most significant was the 'Shooting Series', a group of four paintings created and exhibited between 1767 and 1770 showing two men out shooting in the course of a day, from dawn to dusk (figs.48–51).[7] The first picture was exhibited with the Society of Artists in 1767 under the title 'Two gentlemen going a shooting, with a view of Creswell Craggs; taken on the spot'. As was noted in the previous chapter, Creswell Crags was on the estate of the Duke of Portland. So the pictures could be interpreted as depicting aristocratic activity, an important point as the long-standing Game Laws specified that only substantial landowners could legitimately hunt and a more recent

48 George Stubbs
*Two Gentlemen Going a Shooting, with a View of Creswell Crags, Taken on the Spot c.*1767
Oil on canvas
101.6 × 127.2
(40 × 50⅛)
Yale Center for British Art, New Haven

49 George Stubbs
*Two Gentlemen Going
a Shooting* 1768
Oil on canvas
101.5 × 127.2
(40 × 50)
Yale Center for
British Art, New
Haven

revision of the law even specified that only the wealthy could own guns. In this case, the work could be interpreted in the same way as his subsequent portrait of Sir John Nelthorpe out hunting with his dogs in an identifiable landscape, Barton Fields, within the lands that he owned (fig.52). But in 1769 William Woollett, one of the most prominent printmakers of the day (prominent enough that in this case he may have passed off the handiwork of Thomas Hearne as his own), engraved the first composition.[8] Significantly, the print made no reference to Creswell Crags; moreover, the accompanying verses specified that these two men had escaped the 'smoky town'; that is, they were city folk, not landowning country gentlemen. At this point, the Game Laws were under heavy criticism, as failing to recognise social mobility and even as an affront to longstanding liberties rooted in ancient law. Critics of the laws asserted the rights of city dwellers to enjoy the pleasures of country life. Between them, Stubbs, Woollett, and the author of the verses stressing the healthiness and moral virtue of being in the country that accompany the prints, conspired to create a set of images calculated to appeal to the 'country boy' among those who live in the 'smoky town'. A non-specific image of nature was contrived to appeal to a broad audience – an audience extending far beyond the small clientele of landowners Stubbs more regularly served.

With the *Haymakers* and *Reapers* Stubbs was hoping to address that audience again. Prints of rural scenes, very often using the soft tonalities available with stipple engraving (the technique used for Stubbs's 1791 reproductions of these pictures) always sold well. What is important to note is that these exhibitions and prints were primarily aimed at an urban audience. These rural images offered them a mythic, idealised vision of the countryside as the location of sure and timeless values and an assurance of the heartiness of country living. Typical of the genre is Thomas Hearne's watercolour, *Summertime* (fig.53), probably exhibited at the Society of Artists in 1783 and quite possibly a direct model for Stubbs when he came to compose his *Haymakers*. Drawing on James Thomson's popular poetic *The Seasons* (1730), Hearne presents the countryside as a place where joyful labour follows the course of the seasons, where rural work is naturalised as part of the cycle of nature in contrast to the social realities of industrial unrest and economic modernisation. But where mainstream images of rural labour tended to stress something of the raggedness of the workers, offering their tatty clothes as both a confirmation of the 'naturalness' of the scene, and for their 'picturesque' interest, Stubbs's labourers are strikingly clean and tidy. The men wear buckled shoes and breeches that would have proved uncomfortable to bend down in, and the women are fashionably dressed. We know from contemporary accounts that farm

50 George Stubbs
Two Gentlemen Going a Shooting c.1769
Oil on canvas
99.1 × 124.5
(39 × 49)
Yale Center for British Art, New Haven

51 George Stubbs
A Repose after Shooting 1770
Oil on canvas
102.2 × 128.3
(40¼ × 50½)
Yale Center for
British Art, New
Haven

labourers might be better dressed than we would anticipate, and that women who worked seasonally might come on to the land in the costumes they would normally wear for their other work, for instance in service, which would have required a degree of smartness. But even so, Stubbs's workers have a cleanliness that is improbable given the work they are undertaking, and which certainly doesn't provide for the sentimental cooing from city-dwellers that such imagery was meant to elicit. They are, instead, organised into almost mechanical rhythms. In the *Haymakers* the workers are arranged into a tidy pyramid, each figure taking up a role in a neat sequence of events; in the *Reapers*, they are choreographed into a gently undulating wave of activity, with the church spire, and the mounted farm overseer, and the row of towering, ancient-looking oaks, combining to establish the presence of the economic, religious and temporal authorities that ruled over their lives. Both pictures contrive an image of strict order, perhaps too strict and unreal for contemporary tastes. Stubbs may have calculated that in a time of rising rural problems, his urban audience would have wanted to know that agricultural labourers were sternly disciplined. If so, he miscalculated. The original exhibition of the *Haymakers* and *Reapers* in 1786 drew a great deal of criticism, as yet again the writers on art resisted the artist's attempts to move outside of animal painting. If the

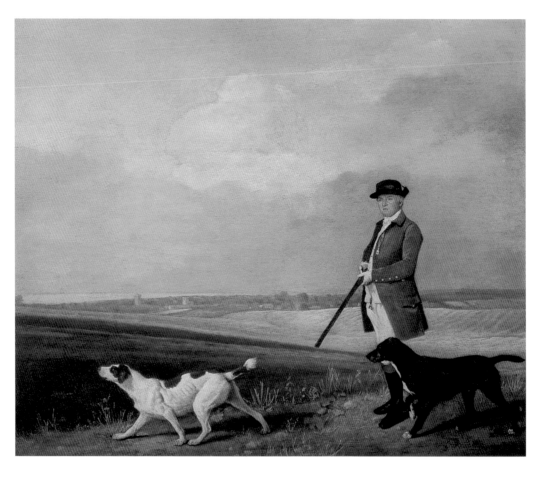

52 George Stubbs
*Sir John Nelthorpe,
6th Baronet, out
Shooting with his
Dogs in Barton Fields,
Lincolnshire* 1776
Oil on panel
61 × 71.1 (24 × 28)
Private Collection

53 Thomas Hearne
Summertime 1783
Pencil, pen, ink
(brown) and
watercolour
28.3 × 33.4
(11⅛ × 13⅛) oval
Whitworth Art
Gallery, University of
Manchester

1977 campaign established the works as masterpieces of British art, the critic of the *Morning Post* (6 May 1786) had the quite opposite opinion: 'In horses this artist stands unrivalled; as to his reapers, no injury would have been done to his fame, had they been entirely omitted. How difficult to persuade a man to pursue his *forte*.' While the critic of the *Daily Universal Register* (17 May 1786) praised the artist for 'returning to his associated brethren, and conquering his resentments' by choosing to exhibit at the Academy after several years, he also noted that 'Animals are the *forte* of this master; undoubtedly the figures want taste in their disposition, and the arrangement has too Gothic an appearance.' What is meant by 'Gothic' is an antiquated formality, associated with what we would characterise as pre-Renaissance and Early Renaissance art, but also deployed more generally to conjure associations with dry precision that fell outside of academic aesthetic regulations whose proclaimed aim was a more poetic breadth that would reflect on the intellect of the painter. The 'Gothic' artifice of these scenes meant that if these subjects were an attempt to address a market, they failed. All the different versions seem to have remained with the artist until his death and the prints published in 1791, like most of his prints, did not sell well.

That the *Haymakers* and *Reapers* did not appeal to Stubbs's contemporaries can readily be established. The manner in which we recover them as works of art today is a different matter. In 1977 and beyond the insistent claim was that they represented the truth about the English and their country, in a way which stood outside of the desires and needs of any individual. They were claimed not as historical documents, but as confirmations of the national character which superseded historical circumstance. In the year of the Jubilee and the Sex Pistols, perhaps this confirmation was needed more than ever.

5

'WHERE CAN A FELLOW RIDE?'

A sheep and a horse confronting each other calmly on a neat lawn in front of a neat fence (fig.54); a life-size racehorse stretching out monumentally (fig.55); the skeleton of a chicken, striding forcefully to the left (fig.57); a skinned man, running to the left quite as purposefully (fig.58); a row of soldiers, fat and thin, lined up like toys (fig.60). These images, produced by Stubbs in the last decade of so of his life are as curious as they are memorable. They are images that testify to the awkward place in relation to the art world of his day Stubbs occupied from the outset, and the awkward place in art history he has held since. Not sporting art or portraiture in a conventional sense, not scientific illustration in a straightforward fashion, these are images whose curious character reveals something of the essence of Stubbs's isolation as an artist.

The image of the horse, called Dungannon, with a sheep, who remains unnamed, is a print produced by George Townley Stubbs after the painting by his father that was included in the 'Turf Gallery' (fig.54). This project was initiated in 1790 when an unidentified 'Mr Turf' (possibly the Prince of Wales, who supported the artist generously in the early 1790s) approached him with the idea and the offer of financial backing. The intention was that the gallery would display paintings by Stubbs of famous horses, attracting subscriptions for a series of prints of those paintings: the original aim was that the series would stretch to 145 separate images, accompanied by a text describing the history of horseracing. The project was a preoccupation for Stubbs during the early 1790s. He failed to exhibit at the Royal Academy from 1791 right through to 1799, and when the gallery finally opened in Conduit Street in 1794 the *Sporting Magazine* welcomed the exhibition as an opportunity finally to see his works again.[1] There had been a number of comparable projects over recent years. Most significant were the various galleries of paintings on patriotic literary and historical themes set up at the end of the 1780s by the publishers John Boydell, Robert Bowyer and Thomas Macklin, which were similarly meant to create interest for the sale of prints reproducing pictures on show there. Although the gallery was warmly welcomed and extensively covered by the *Sporting Magazine*, it does not seem to have gathered much wider interest.[2] It closed in 1798, with only a handful of the proposed prints published. The explanation offered by Humphry's *Memoir* was that the current war with France had made the exportation of prints impossible and the scheme unworkable.[3] We know that the other commercial galleries of the time suffered from this. But in the case of the Turf Gallery the economic situation may only have aggravated its existing difficulties in finding a public. The Gallery can be interpreted as part of a wider effort in the 1790s to create pub-

lic interest in the values of sporting culture, something the *Sporting Magazine* itself was concerned with, and similarly failed to achieve. It has been suggested that inclusion of the sheep in the image of Dungannon was an allusion to British agriculture, with the evident healthiness of both creatures proving a patriotic celebration of national achievements in animal husbandry (a particular concern in the present state of war).[4] Stubbs's deliberately bland, 'scientific' depiction of the animals (carried through to the texts accompanying the prints 'specifying the races & matches with particular anecdotes and properties of each horse') hardly helps convey that message.[5] By this date he was falling out of favour with the patrons of sporting art, who were turning to painters either cheaper or able to produce works of greater painterly or anecdotal interest (or a combination of these). Also, as a big part of the appeal of the other commercial galleries was the sheer range and variety of works by different artists on display, a gathering of so many paintings by Stubbs following the same formula did not perhaps have tremendous appeal (even in the much bigger and more various Tate Gallery show of 1984, there were some critics who said the same).

The life-size horse is Hambletonian (fig.55). In 1799 the young and rakish Sir Henry Vane-Tempest commissioned Stubbs to paint this animal, who had in March won a race for him at Newmarket against Joseph Cookson's Diamond for a bet of a massive 3,000 guineas. Already a winner at the St Leger and the Doncaster Gold Cup, the race against Diamond was not only notable because of the huge amount of money at stake, but also because in 1797–8 his racing career looked as if it was coming to an end with lameness. According to contemporary reports, the race was vicious, with both horses being whipped and goaded until they bled. Hambletonian won by just half a neck.

Two works were commissioned by Vane-Tempest to celebrate his horse's victory. One was to show Hambletonian at the moment of winning the race. This may never have existed as anything more than a drawing and is known now only from a copy painted by the younger animal artist James Ward. The other, which survives to be widely reckoned as the artist's masterpiece, shows Hambletonian being rubbed down after the race. Both pictures were exhibit-

54 George Townley Stubbs after George Stubbs
Dungannon 1794
Stipple with etching
39.1 × 50.4
(15¾ × 19⅞)
Yale Center for British Art, New Haven

55 George Stubbs, *Hambletonian, Rubbing Down* 1799–1800
Oil on canvas 209 × 367.3 (82¼ × 144⅝)
Mount Stewart, The National Trust

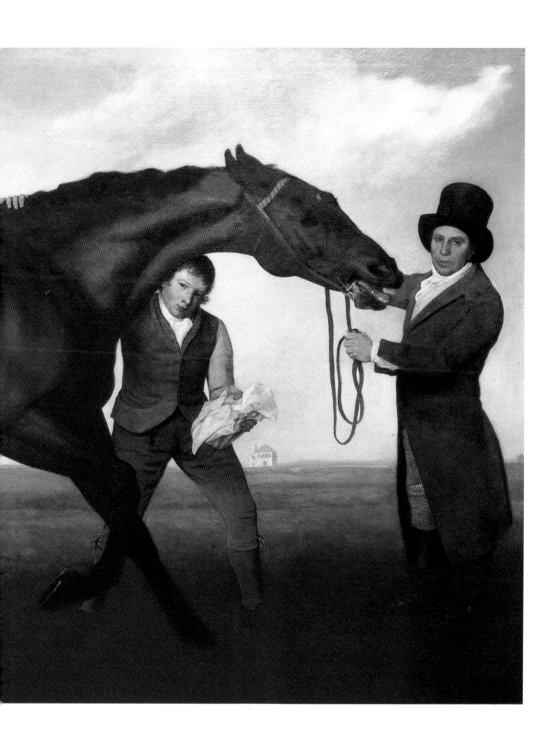

ed at the Academy in 1800, one in the Great Room and the other in the Library (usually reserved for drawings and models). The display of whichever work in the Library was a slight on the artist, the diarist Joseph Farington noting that it was shown there with a picture by James Ward which had been relegated to that space because it was considered 'a Staring thing'.[6] Although it has been argued that *Hambletonian, Rubbing Down* must have been shown in the Great Room, the fact that Farington saw fit to record this remark, and that one newspaper critic claimed that a portrait by Lawrence which is somewhat smaller than Stubbs's painting was the largest canvas in the Great Room, suggests that it was, in fact, the painting that was shown in this space, where it must have appeared cramped and would easily have been overlooked. Certainly, the work drew little comment in the press, the *Morning Herald* noting, unusually, that the human figures were better conceived than the horse which is 'calculated to give but a very slender idea of the superior swiftness of his speed'.

For reasons unknown, Vane-Tempest refused to pay the price demanded by Stubbs. The case went to court, with George Garrard, Ozias Humphry and the portrait painter Thomas Lawrence presenting evidence on Stubbs's side while John Opie and John Hoppner were 'very violent against the claim'.[7] Such a case was not unknown. Stubbs himself had appeared in support of George Garrard in 1797 when a patron disputed the price he was charging for a sporting picture and when in 1804 John Singleton Copley demanded 1,800 guineas for a picture, Stubbs was reportedly one of the artists who supported him in his claim.[8] While Stubbs won his case, the affair may have damaged his professional reputation, Farington noting shortly afterwards that when he was asked by a potential patron who might be suitable to paint his horse: 'I recommended Garrard, as I concluded Stubbs wd. be too expensive.'[9]

Unless some new document comes to light, we will never know why Vane-Tempest refused to pay Stubbs. But we can recall criticisms of earlier works,

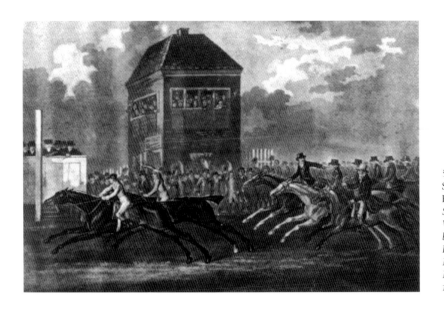

56 After John Nost Sartorious
Engraving
Sir Henry Temple-Vane's Hambletonian beating Mr Cookson's Diamond at the Craven Meeting, Newmarket, Monday 25th March 1799

regarding his treatment of landscape, the artificiality of his imagery, his inability to create visual interest in his painted surfaces, and apply them all here. The sterile and barren landscape recalls directly Stubbs's views of Newmarket from the 1760s. Compared to a contemporary, more conventional image of the event (fig.56), Stubbs fails to give any obvious sense of the excitement of the race or any simply explicit understanding (as the *Morning Herald* noted) of the achievement of the horse. Here, fragmented and disrupted by the horse, the landscape creates a strangely anti-dramatic contrast with the dramatic figure of the animal. Glimpsed through Hambletonian's legs, the featureless landscape is dwarfed, emphasising the way that the horse dominates the canvas to an uncomfortable degree. The static figure of the groom with a

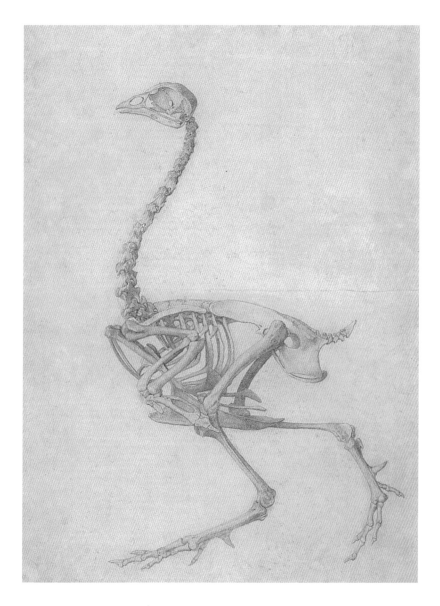

57 George Stubbs
*Fowl Skeleton, Lateral
View* c.1795–1804
Graphite 54 × 40.6
(21¼ × 16)
Yale Center for
British Art, New
Haven

top hat is made to look stunted, and the stable boy is shown actually having to stoop down to be seen. Hambletonian is monumentalised as Whistlejacket had been forty years earlier, but here the introduction of the conventional accompanying elements puts the horse into a relationship with awkward-looking humans and so deprives the viewer of the complete assurance that this animal should be viewed as an art object that the blank background of the earlier work supplied. The horse is presented as a living, owned, cared-for creature, and as such its overwhelming physical presence is given a context that refers to the reality of its existence. Vane-Tempest may have been very proud of his horse, but he perhaps did not expect a picture that would cajole, even intimidate him into being proud. In earlier years, Stubbs's ambitions to elevate the genre of horse painting had coincided neatly with the desires of his patrons. Now, at the beginning of the nineteenth century, he was rebuffed for his ambition.

The great expanse of Hambletonian, stretched out across the canvas at the expense of all the other elements, draws the greatest attention to Stubbs's ability to conjure the texture and colour of its skin. It is, almost, pinned out like a scientific specimen. The descriptive and classificatory impulse which informs this work found its clearest expression in the project that occupied Stubbs from 1795 until his death: drawings of dissected tigers, chickens and humans that would provide the basis of the engravings that would illustrate a huge work of comparative anatomy, 'shewing the analogy between the Human frame, the Quadruped and the fowl, giving also an accurate description of the bones, cartilages, muscles, fascias, ligaments &c &c (which he intended to have carried on to the vegetable world)'.[10] Over 120 drawings and four volumes of text (two in French) survive, revealing the gigantic scale of the publication he had in mind. The man, the tiger and the chicken are shown in closely comparable positions, from the front, from the side and from behind, with their skin, stripped of their skin and reduced to a skeleton (figs.57, 58).

Stubbs died in July 1806 without seeing the *Comparative Anatomy* being published in full. Only half the planned plates had been issued. His last words, according to Humphry, were: 'I fear not death, I have no particular wish to live. I had indeed hoped to have finished my Comparative Anatomy eer I went, but for other things I have no anxiety.'[11] A professional artist for some sixty years, he still appears to have been at his death substantially in debt to one of his patrons, Lady Isabella Saltonstall. The monies raised by the sale of his works had to go to her, and the diarist Joseph Farington noted that: 'It is understood that after Her debt is paid there will be little left.'[12]

The *Comparative Anatomy* should have been Stubbs's great, final monument. But the publication of the prints went entirely unnoticed. The idea of examining comparatively the anatomies of men and animals was very current, particularly in France (which may explain Stubbs's intention to publish a version of the text in French). But he was by this date an isolated figure, and his approach, essentially the same as that employed on the *Anatomy of the Horse* forty years earlier, was quickly to become anachronistic, as the technical and professional languages of science and of art parted ways.[13] His illustrations propose a complete fusion of the aesthetic and the scientific. Each

58 George Stubbs
Human Figure,
Lateral View, Skin and
Underlying Fascial
Layers Removed
*c.*1795–1804
Graphite 48.9 × 38.7
(19¼ × 15¼)
Yale Center for
British Art, New
Haven

figure is animated, as if alive, lit and posed not just as an object of study, but as an object of beauty. Viewed in historical perspective, this is a final monument of the Enlightenment belief in the power of art to persuade us of truth. With the vast acceleration of images and our current consciousness of 'virtuality', we are hardly in a position to be persuaded of the validity of these artful images as truth. The comparisons drawn (literally) between man and animal now look to us ludicrous and we could ask, what are we really meant to learn from the comparison? That men move like tigers, and tigers move like chickens? Is that demonstrated by these frozen contrivances? Each figure is contained in a featureless vacuum, coming from nowhere, going nowhere. The drawings for the *Comparative Anatomy,* his paintings of animals, even of men, ask us to find in the descriptions of surfaces and structures some kind of truth. It is the question that is asked by Stubbs's art as a whole. A pair of fox-

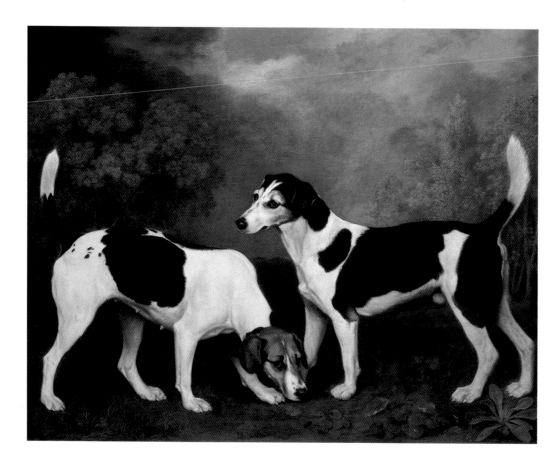

hounds is presented so boldly and blandly that we have to engage in a process of comparison and contrast, and are forced to attend to the specificities of pat-terning (fig.59). Will their surfaces yield some secret knowledge because of the brilliance with which the artist has described them? His soldiers, lined up like specimens, invite us to compare and contrast these figures in the same way as those dogs, or even in the same way as we read van Rymsdyck's image of a chick in different stages of its development (figs.60, 5). Are these men just specimens? In Stubbs's art all existence is reduced to visual spectacle, which, beyond the world of animal painting he so wanted to escape – where art was there to document property for its owners, is of uncertain status and mean-ing. Stubbs offers us a vision of nature, human and animal, dissected, classi-fied, put under an unrelenting light, and reduced to a mechanical essence which is visually fascinating, but may also be emptied of narrative, emotional or social content. Perhaps we should be more uncomfortable with Stubbs than we are.

59 George Stubbs
A Couple of Foxhounds 1792
Oil on canvas
101.6 × 127
(40 × 50)
Tate

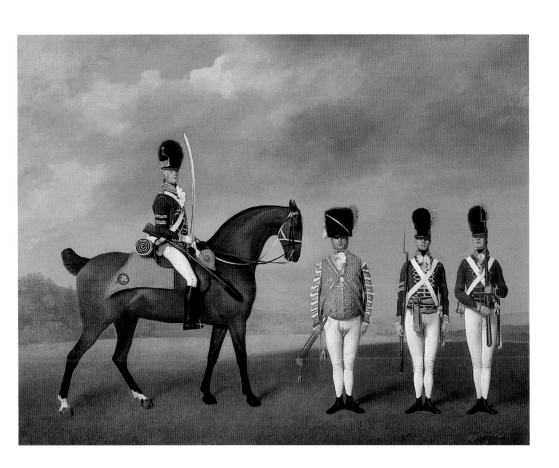

60 George Stubbs
Soldiers of the 10th
Light Dragoons 1793
Oil on canvas
102.2 × 127.9
(40¼ × 50⅜)
The Royal Collection

Notes

Introduction: A Portrait of the Artist as a Young Obstetrician

1 In the Record Office and Local History Department of Liverpool City Libraries; published in Nicholas H.J. Hall, *Fearful Symmetry: George Stubbs, Painter of the English Enlightenment*, exh. cat., Hall & Knight Ltd, New York 2000, pp.195–212; hereafter referred to as Humphry, *Memoir*.

2 Joseph Mayer, *Early Art in Liverpool and Notes on the Life of George Stubbs, RA*, Liverpool 1876. Stubbs's authorship of the Burton plates had been earlier suggested by 'R.W.F.' in *Notes and Queries*, 3rd series, vol.5, 25 June 1864, p.5254.

3 Alan Doherty, *The Anatomical Works of George Stubbs*, London 1974, p.VII.

4 Tony Godfrey, 'Stubbs and Laocoon', *Artscribe*, January/February 1985, pp.36–9.

5 *Monthly Magazine* 1806, p.603; *Sporting Magazine*, July 1808, p.55.

6 *Gentleman's Magazine*, vol.76, part 2, 1806, pp.978–9.

7 Basil Taylor, *George Stubbs 1724–1806*, exh. cat., Whitechapel Art Gallery 1957, p.6.

8 Geoffrey Grigson, 'George Stubbs, 1724–1806', in *The Harp of Aeolus*, London 1948, pp.14–15.

9 Richard Godfrey, 'George Stubbs as a Printmaker', in Hall, *Fearful Symmetry*, pp.53–4.

10 R.B. Fountain, 'Some Speculations on the Private Life of George Stubbs 1724–1806', *The British Sporting Art Trust Essay* 12 (1984).

11 Kenneth Garlick *et al.* (eds.), *The Diary of Joseph Farington*, 17 vols, New Haven and London 1978–98, VIII, p.2854 (19 September 1806).

12 Ronald Paulson, *Emblem and Expression: Meaning in English Art in the Eighteenth Century*, London 1975; David Solkin, *Painting for Money: The Visual Arts and the Public Sphere in Eighteenth-Century England*, New Haven and London 1993.

13 William Vaughan, *British Painting: The Golden Age from Hogarth to Turner*, London 1999, p.167.

14 Jonathan Sawday, *The Body Emblazoned: Dissection and the Human Body in Renaissance Culture*, London and New York 1995, p.1.

15 See Roy Porter, 'A Touch of Danger: The Man-midwife as Sexual Predator' in G.S. Rousseau and Roy Porter (eds.), *Sexual Underworlds of the Enlightenment*, Manchester 1987, pp.206–32.

16 See Ruth Richardson, *Death, Dissection and the Destitute*, London and New York 1987, pp.52–72.

17 Thomas Amory, *The Life of John Buncle*, 2 vols., 1756, II, p.445.

Chapter One: 'Making Himself Known'

1 Richard and Samuel Redgrave, *A Century of British painters* (1866), London 1947, p.135.

2 Walter Shaw Sparrow, *British Sporting Artists*, London 1922, p.116.

3 'Antony Pasquin' (John Williams), *Memoirs of the Royal Academicians*, London 1796, p.124.

4 George Vertue, *Notebooks*, 6 vols., Walpole Society (1930–55), III, p.91.

5 Humphry, *Memoir*, p.201.

6 Humphry, *Memoir*, p.201.

7 Humphry, *Memoir*, p.202.

8 *London Tradesman*, April 1747.

9 'Memoirs of George Stubbs, Esq', *The Sporting Magazine*, May 1808, pp.55–7 (p.56).

10 Humphry, *Memoir*, p.202.

11 Humphry, *Memoir*, p.202.

12 Humphry, *Memoir*, p.211.

13 Humphry, *Memoir*, p.202.

14 Horace Walpole to Richard Bentley, 15 August 1755, *The Yale Edition of Horace Walpole's Correspondence*, 48 vols., Oxford and New Haven 1937–83, XXXV, p.243.

15 *Monthly Review* 36 (1767), p.160; Humphry, *Memoir*, p.210.

16 Humphry, *Memoir*, p.202.

17 Vertue, *Notebooks*, III, p.86.

18 Humphry, *Memoir*, p.202.

19 *The Idler*, 29 September 1759, in Sir Joshua Reynolds, *Discourses*, Pat Rogers (ed.), Harmondsworth 1992, p.347.

20 Stephen Deuchar, *Sporting Art in Eighteenth-Century England: A Social and Political History*, New Haven and London 1988, pp.109–10.

21 Deuchar, *Sporting Art*, pp.107–8.

Chapter Two: 'A Man Who Painted Racehorses'

1 André Rouquet, trans. anon., *The Present State of the Arts in England*, London 1755, p.58.

2 Advertisement quoted in William T. Whitley, *Artists and their Friends in England 1700–1799*, 2 vols., London 1928, I, pp.78–9.

3 'Antony Pasquin' (John Williams), *A Critical Guide to the Exhibition of the Royal Academy for 1796*, London 1796, p.124.

4 P.J. Grosley, trans. Thomas Nugent, *A Tour to London*, 2 vols., London 1772, I, pp.156–8.

5 Daniel Defoe, *A Tour Through the Whole Island of Great Britain*, first published 1724–6, Harmondsworth 1971, p.98.

6 Richard Cumberland, *The Note of Hand; Or, Trip to Newmarket*, London 1774, 'Epilogue'.

7 Jocelyn de Moubray, *Horse-Racing and Racing Society: Who Belongs and How it Works*, London 1985, p.3.

8 Richard Baker, *Observations on the Pictures now in Exhibitions*, London 1771, pp.10–11.

Chapter Three: 'Un-natural Fictions'

1 Joseph Mayer, *Early Art in Liverpool and Notes on the Life of George Stubbs, RA*, Liverpool 1876, p.93.

2 Sir Robert Witt, *The Times*, 25 February 1944, p.5.

3 Alfred Munnings, *An Artist's Life*, 3 vols., London 1950–2, III, p.32.

4 Basil Taylor, 'George Stubbs: "The Horse and Lion" Theme', *Burlington Magazine* 107 (1965) pp.81–6.

5 Edward Fryer (ed.), *The Life and Works of James Barry*, 2 vols., London 1809, I, p.23.

6 Published in the *Public Advertiser* 4 November 1763, reprinted in Frederick W. Hilles and Philip B. Daghlian (eds.), *Anecdotes of Painting in England (1760–1795) ... Collected by Horace Walpole ('Volume the Fifth and Last')*, New Haven and London 1937, pp.110–12.

7 James Greig (ed.), *The Diaries of a Duchess: Extracts from the Diaries of the First Duchess of Northumberland (1716–1776)*, London 1926, p.207 (June 1773).

8 Judy Egerton, 'Enamel Painting on Copper and Stubbs', in Hall, *Fearful Symmetry*, pp.49–52.

9 Bruce Tattersall, *Stubbs & Wedgwood: A Unique Alliance Between Artist and Potter*, exh. cat. Tate Gallery, London 1974; Robin Emmerson, 'Stubbs and Wedgwood: New Evidence from the Oven Books', *Apollo*, August 1999, pp.50–5.

10 Josiah Wedgwood to Thomas Bentley, 21 October 1780, in Tattersall, *Stubbs & Wedgwood*, p.111.

11 Josiah Wedgwood to Thomas Bentley, 21 October 1780, in Tattersall, *Stubbs & Wedgwood*, p.115.

12 Josiah Wedgwood to Thomas Bentley, 28 October 1780, in Tattersall, *Stubbs & Wedgwood*, p.115.

13 Humphry, *Memoir*, p.209.

14 Gilbert Ironside, 'A Dissertation on Horses' in *Supplement to the General Stud-book*, London 1800, pp.15–16.

15 Anon., *Le Pour et le Contre: Being a Poetical Display of the Merit and Demerit of the Capital Paintings exhibited at Spring Gardens*, London 1767, p.15.

16 *Public Advertiser*, 1 May 1764; 'Peter Pindar' (John Wolcot), *Lyrical Odes to the Royal Academicians*, London 1782, Ode VII.

Chapter Four: 'A Country Boy at Heart'

1 Judy Egerton, 'George Stubbs and the 'Haymakers' and 'Reapers' of 1785', catalogue of Bonham's 'Special Auction to Support the Tate Gallery National Appeal to Save the Stubbs', 8 December 1977.

2 Bulwer Lytton, *England and the English*, 2 vols., New York 1833, I, p.57, quoted in Paul Langford, *Englishness Identified: Manners and Character 1650–1850*, Oxford 2000, p.29, followed by a discussion of the role of 'industry' in ideals of Englishness (pp.29–36).

3 Judy Egerton, memo to Martin Butlin, 30 November 1977 (Tate Archive).

4 Richard Cork on BBC Radio 4's 'Kaleidoscope', broadcast 27 January 1978.

5 'Impartial Hand', *The Exhibition: Or, A Candid Display of the Genius and Merits of the Several Masters, whose Works are now offered to the Public, at Spring Gardens*, London 1766, p.9.

6 *Tate Gallery 1976–8: Illustrated Biennial Report and Catalogue of Acquisitions*, p.13.

7 Deuchar, *Sporting Art*, pp.114–21.

8 *Diary of Joseph Farington*, XIV, p.5006 (20 April 1817).

Chapter Five: 'Where Can a Fellow Ride?'

1 *Sporting Magazine*, May 1794, p.167.

2 'Description of the Pictures now exhibiting at the Turf Gallery', *Sporting Magazine*, January 1794, pp.210–14.

3 Humphry, *Memoir*, p.207.

4 Deuchar, *Sporting Art*, p.165.

5 Humphry, *Memoir*, p.207.

6 *Diary of Joseph Farington*, VI, p.2278 (26 March 1804).

7 *Diary of Joseph Farington*, IV, p.1536 (9 April 1801).

8 The Garrard case is detailed in Judy Egerton, 'A Painter, a Patron and a Horse', *Apollo*, October 1985, pp.268–9; the Copley case reported in *Diary of Joseph Farington*, VI, p.2256 (1 March 1804).

9 *Diary of Joseph Farington*, IV, p.1574 (8 July 1801).

10 Humphry, *Memoir*, p.207.

11 Humphry, *Memoir*, p.208.

12 *Diary of Joseph Farington*, VIII, p.3056 (3 June 1807).

13 See Alex Potts, 'Natural History and the Call of the Wild: the Politics of Animal Picturing', *Oxford Art Journal*, 13:1 (1990), pp.12–33.

Chronology

1724 Born in Liverpool, 25 August, son of John Stubbs, currier, and Mary.

1741 Works briefly with Hamlet Winstanley copying pictures at Knowsley Hall, near Liverpool.

1742–5 Living in Liverpool, Leeds and Wigan, painting portraits and dissecting animals.

1745–53 Living in York. Studies and then teaches at York Hospital, and produces illustrations for John Burton's *Essay Towards a Complete New System of Midwifery* (1751). Paints portraits, and moves to Hull.

1754 Recorded in Rome, staying at the Piazza di Spagna.

1755 Returns to Liverpool.

1756–8 Dissecting horses at a farmhouse in Horkstow, Lincolnshire, assisted by Mary Spencer; birth of George Townley Stubbs, presumed to be their son (1756–1815).

1758 Moves to London.

1760–2 Engaged in commissions for sporting and animal pictures for the Duke of Richmond, Lord Grosvenor, the Marquess of Rockingham and others.

1762 Shows four pictures with the Society of Artists in London, including *Phaeton and the Chariot of the Sun*; exhibits regularly with them through to 1774.

1763 Exhibits *Horse Frightened by a Lion* and *Horse Devoured by a Lion* with the Society of Artists; moves to 24 Somerset Street, where he lives until his death.

1765 Paints *Gimcrack with John Pratt Up*, *Turf with Jockey Up* and studies of Newmarket Heath.

1766 Publication of *Anatomy of the Horse*; elected a Director of the Society of Artists.

1767–70 Paints and exhibits the 'Shooting Series'.

1769 First experiments with enamel painting on copper; publication of William Woollett's engravings of the 'Shooting Series' begins.

1770 Paints *The Duke of Richmond's First Bull Moose* for William Hunter; first print after Stubbs engraved by George Townley Stubbs.

1772 Elected President of the Society of Artists.

1775 Begins association with Josiah Wedgwood; begins to exhibit with the Royal Academy.

1777 First paintings on Wedgwood ceramic tablets; publishes etching of *A Horse Affrighted by a Lion*.

1780 Elected Associate of the Royal Academy; stays at Etruria with the Wedgwood family; paints their portraits and produces designs for ceramic wares.

1781 Elected Royal Academician; exhibits his first enamel paintings at the Academy.

1786 Exhibits *Haymakers* and *Reapers* at the Academy.

1788 Publication of twelve prints by Stubbs, mainly animal subjects (1 May).

1790 Turf Gallery project initiated.

1791 Exhibits at the Royal Academy for the last time until 1799; paints *A Rhinoceros* for John Hunter.

1791 Publishes stipple engravings of *Haymakers* and *Reapers*.

1793 Paints group of works for George, Prince of Wales, including *Soldiers of the 10th Light Dragoons*.

1794 Turf Gallery opens in Conduit Street, London, under the management of George Townley Stubbs.

1795 Begins work on drawings of dissected humans, tigers and other animals for the *Comparative Anatomy*.

1797 Ozias Humphry records his memoirs.

1798 Closure of the Turf Gallery, with only 14 of the projected 145 prints published.

1801 Lawsuit against Henry Vane-Tempest over payment for *Hambletonian, Rubbing Down*.

1803 Exhibits at the Royal Academy for the last time.

1804 First plates of the *Comparative Anatomy* issued.

1806 Dies at his home at 24 Somerset Street, London (10 July).

Photographic Credits

Select Bibliography

Barrell, John, *The Dark Side of the Landscape: The Rural Poor in English Painting 1730–1840*, Cambridge 1980.

Barrell, John, 'The Transcendence of Property', *Times Literary Supplement*, 9 November 1984, p.1285.

Brewer, John, *The Pleasures of the Imagination: English Culture in the Eighteenth Century*, London 1997.

Cormack, Malcolm, *et al.*, *George Stubbs in the Collection of Paul Mellon*, exh. cat., Yale Center for British Art, New Haven 1999.

Deuchar, Stephen, *Sporting Art in Eighteenth-Century England: A Social and Political History*, New Haven and London 1988.

Doherty, Alan, *The Anatomical Works of George Stubbs*, London 1974.

Egerton, Judy, *George Stubbs: Anatomist and Animal Painter*, exh. cat. Tate Gallery, London 1976.

Egerton, Judy, *George Stubbs (1724–1806)*, exh. cat. Tate Gallery, London 1984.

Fountain, Robert and Alfred Gates, *Stubbs' Dogs: The Hounds and Domestic Dogs of the Eighteenth Century as Seen through the Paintings of George Stubbs*, London 1984.

Hall, Nicholas H.J., *Fearful Symmetry: George Stubbs, Painter of the English Enlightenment*, exh. cat., Hall & Knight Ltd, New York, 2000.

Lennox-Boyd, Christopher, C.R. Dixon and Tim Clayton, *George Stubbs: The Complete Engraved Works*, London 1989.

McKendrick, Neil, John Brewer and J.H. Plumb, *The Birth of a Consumer Society: The Commercialization of Eighteenth-Century England*, London 1982.

Paulson, Ronald, *Emblem and Expression: Meaning in English Art in the Eighteenth Century*, London 1975.

Paulson, Ronald, *Breaking and Remaking: Aesthetic Practice in England, 1700–1820*, New Brunswick and London 1989.

Potts, Alex, 'Natural History and the Call of the Wild: the Politics of Animal Picturing', *Oxford Art Journal*, 13:1 (1990), pp.12–33.

Solkin, David, *Painting for Money: The Visual Arts and the Public Sphere in Eighteenth-Century England*, New Haven and London 1993.

Tattersall, Bruce, *Stubbs & Wedgwood: A Unique Alliance Between Artist and Potter*, exh. cat., Tate Gallery, London 1974.

Taylor, Basil, 'George Stubbs: "The Horse and Lion" Theme', *Burlington Magazine* 107 (1965) pp.81–6.

Taylor, Basil, *Stubbs* (1971), 2nd edn, London 1975.

Index